Where in Maine?

Text by Andrew Vietze

Photography by Kevin Shields

Where in Maine?

A Tour of Intriguing Places in the Pine Tree State

text by Andew Vietze

photography by Kevin Shields

Copyright © 2009 by Down East Enterprise, Inc.

ISBN 978-0-89272-806-0

Library of Congress Cataloging-in-Publication Information available on request.

Design by Miroslaw Jurek

Printed in China.

5 4 3 2 1

Down East

Books • Magazine • Online

www.downeast.com

Distributed to the trade by National Book Network

Where in Maine?

Where in Maine?

For the better part of two decades the editors of *Down East: The Magazine of Maine* have asked our readers to play a game with us. We publish a stunning photograph of a unique location in the Pine Tree State — sometimes instantly recognizable, sometimes not — and drop a few hints about the historical or geological anomalies of this special place. Then we invite our readers to guess where it is by writing us a letter. We also ask them to tell us a little about their own personal connection to this unidentified corner of the Maine landscape. Have they ever visited this waterfall? Do they own a cottage on this island?

To say that "Where in Maine?" is the most popular feature in *Down East* is like calling the view from Cadillac Mountain "pleasant:" an understatement of the highest order. We receive more mail for these short items than other magazines receive for entire issues. The responses range from one-line emails — "It's Perkins Cove in Ogunquit!" — to long, handwritten letters recounting childhoods enjoyed on the pictured shores of Sebago Lake or summers spent at the family cottage overlooking this exact view of Monhegan Harbor.

Browsing through these letters, you realize how precious Maine is to people. For some readers, "Where in Maine?" serves as a test of knowledge: a means of gauging how much of the state they've explored and how much more they have yet to discover. For others, our simple guessing game becomes an emotional conduit that awakens memories of long ago clambakes and campfires.

In this book we've collected forty-six of our best puzzles — artful photographs by Kevin Shields with clever clues from Andrew Vietze — and again, we're inviting you to guess along with us about their locations. You'll find the answer to each entry at the back of the book, along with some almanac-style information we've added to enrich your understanding of Maine. You might recognize a few of these places, you might recognize them all. We can't guarantee how well you'll score. But we can guarantee that you'll emerge from these pages with a greater appreciation for the breath-taking beauty and unique heritage of the state of Maine.

Paul Doiron
Editor in Chief
Down East: The Magazine of Maine

Have you ever sailed to this famed fishing island?

This all could have been yours for a pound of tobacco and a gallon of rum. That, according to local legend, is how much was paid for this midcoast island by the Hanover, Massachusetts, deacon who lent it his name. Though its popularity with tourists today testifies to the island's beauty and charm, you might not have wanted the place back in the eighteenth century. Originally called Newaggin, it was surrounded by small isles known to be popular roosts for pirates, squatters, and assorted rogues. Ghosts, too, supposedly. So maybe smokes and brew were a fair price. Hard to believe so these days, when the roses explode in the bright sun, yachts loll at anchor, and throngs of summer worshipers cascade over the famous bridge here to set up for the season. One of five distinct settlements in a quiet midcoast community — the town itself is said to be home to more isles than any other in the country — the island has a year-round population of about 500 and dangles so far out into the Atlantic people have called it Land's End. It's conjoined to another island — they used to be called the Twins — and was only connected to the mainland in the twenties. It's better known as home to a famous lobster pound than it is for its lobstering fleet, but it nonetheless played an important role in the development of the lobster industry — this is reputed to be where the idea of stringing traps together in long lines was first introduced. It's also where the sport of tuna fishing began in earnest in Maine, and every July the community still hosts a popular tuna tournament. Deep-sea fishing put this island on the map, and helped it become the popular resort it is today. It might not be the pearl of the midcoast — that's a term associated with its twin — but unlike another Maine place with the same name, it's no mistake either. For the name of this famous island, please turn to page 98.

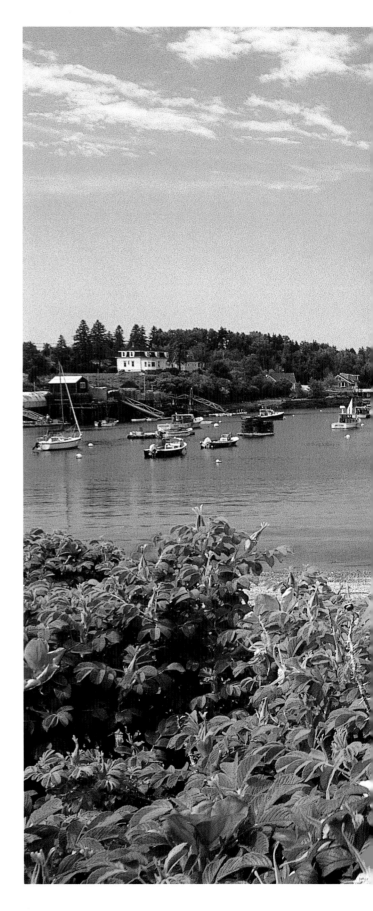

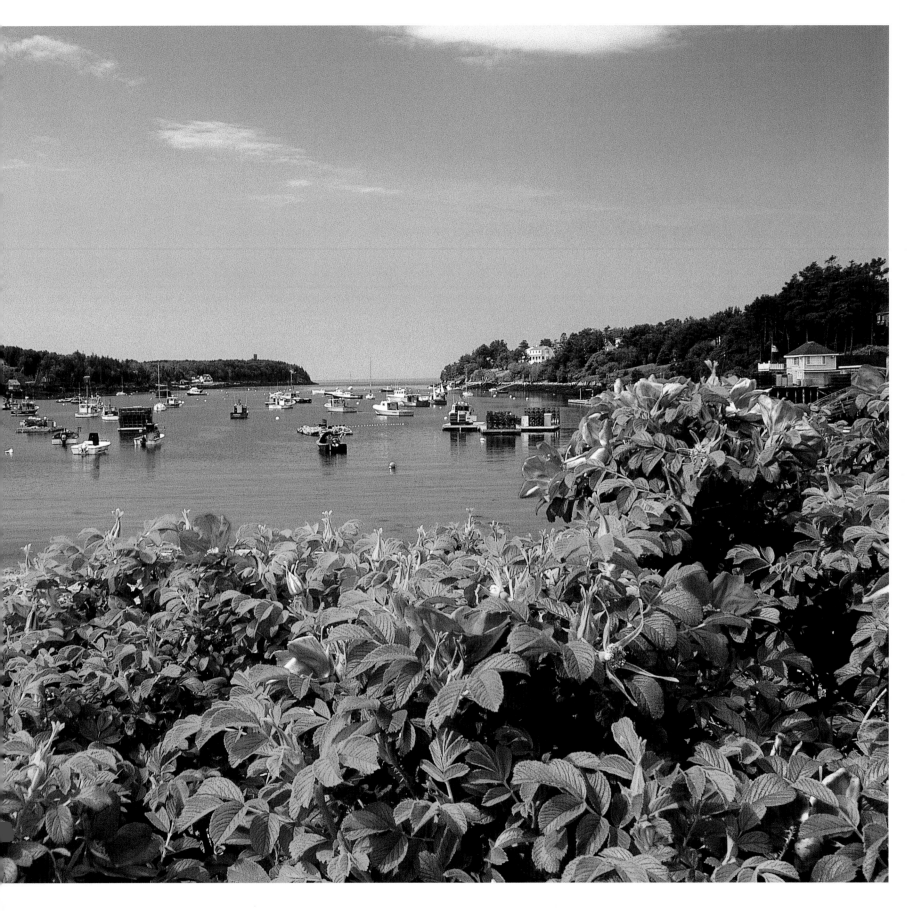

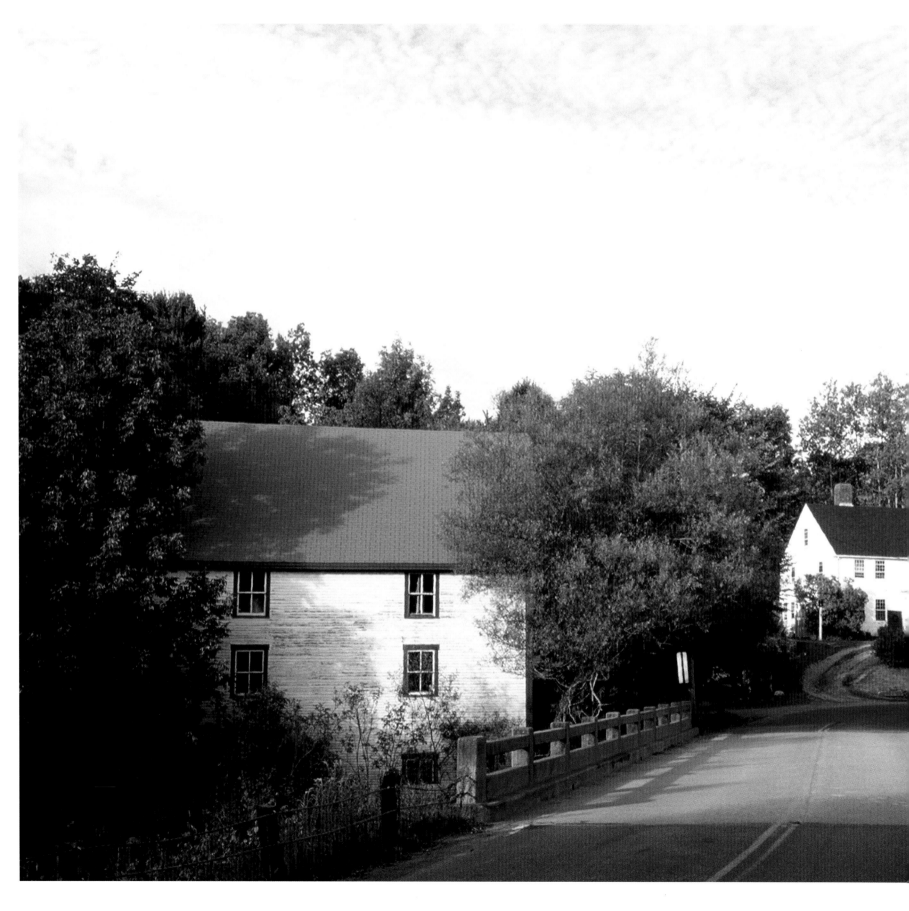

Do you know how this town got its name?

Welcome to New Milford. That's not what this midcoast village is called these days, of course, and it's a good thing, too, because that sounds like some place in Connecticut or Massachusetts. No, this cluster of more than a dozen eighteenth- and nineteenth-century buildings is one of two fine, white-clapboard hamlets in a town named for the prevalence of its alder trees. (Most people are more familiar with these two picturesque villages than they are with the town that contains them.) One of the state's mightiest rivers runs through the community — right under this bridge — and it's the reason for the town's being. The forests along its banks were a pre-Colonial and early-American source of masts for ships. Legendary pirate Captain Kidd is said to have buried Spanish doubloons and diamonds in town when he paid a visit in search of spars, and the white pine masts of the USS *Constitution* spent the winter of 1796–97 here. The heyday of mast production was followed by a lively local shipbuilding industry, an economic mainstay of the community for most of the nineteenth century. Mills of just about every type — saw, grist, stave, shingle, plane, carding, and fulling — were set up in this particular village, and worked away from the late 1700s through the first half of the twentieth century. A freshet flushed out those on the north side of the river in 1896, though, and fire took care of those on the other bank in 1924. When the mills and yards were booming, the town was jumping, like the alewives in the river. Pulitzer Prize-winning poet Edwin Arlington Robinson was born in a house on the bank of the river here in 1869, and he rose to fame penning poems about places like Tilbury Town. (But not New Milford.) To see if you've ever passed through here, turn to page 98.

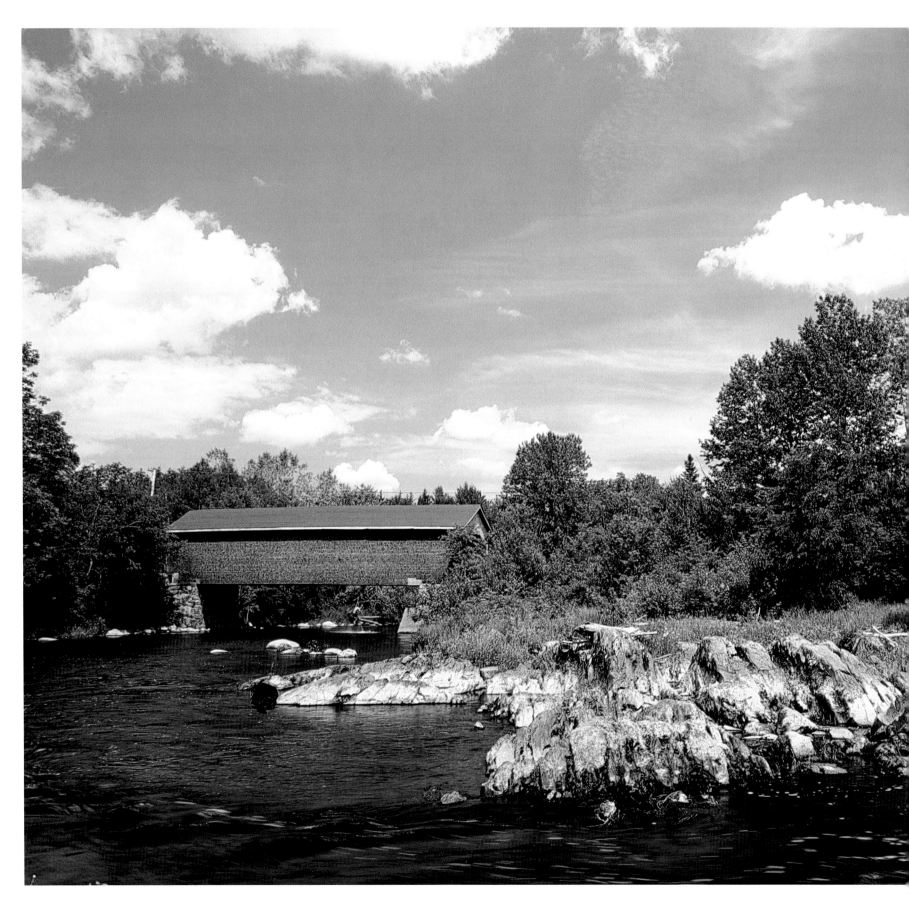

Have you crossed this covered bridge?

Could this be the covered bridge that Jumbo the elephant once walked gingerly through, testing the timbers to make sure that the lions and tigers and bears of P.T. Barnum's circus could cross safely? Perhaps it's the one built under the supervision of Jefferson Davis, before he became president of the Confederacy? Or maybe it's the span that a Portland film company attempted to blow up during the filming of a silent movie? Of course, it couldn't be the latter. Pine Tree Pictures was successful in its bridge demolition and the Union Falls Bridge, like more than 100 of the covered bridges once standing in Maine, was blown into the history books. Because covered bridges have been heavily romanticized as icons of a simpler time, they are all surrounded by legends and lore. This one, too, has its own claim to fame — but it involves neither pachyderms nor rebels. It's the only bridge remaining in Maine to be shingled top to bottom; the others are made of board and batten, lattice, or other types of siding. This span stretches seventy-three feet across Kenduskeag Stream in a quiet section of a town of 2,500 in central Maine whose name alludes to both Greece and a book of the Bible. The bridge is used only for local traffic, one vehicle at a time. There are only nine covered bridges remaining in Maine, which narrows down the odds for those inclined to guess. (As for Jumbo, he stepped lightly across the old international covered bridge between Calais and St. Stephen. According to one report, the elephants were never asked to open their trunks at customs.) To find the location of this storied span, turn to page 98.

Can you identify this 1800s church?

The holidays mean a little something more in this midcoast town. Some historians now believe that the first Thanksgiving in the New World was actually celebrated four hundred years ago not far from the site of this pretty white church. (Sorry, Plymouth. Nice rock, though.) Don't care much about history? Perhaps beaches and celebrities are more your thing? Then you'll be glad to know that one of the finest strands in Maine can be found here. This beach town (population 2,100 or so) played host to the 1999 flick *Message in a Bottle*, starring as the strand on which the very message of the title washes up (Kevin Costner and Paul Newman co-starred). The people who live here tend to associate themselves with several distinct villages — what Maine town isn't broken into several villages, by the way — and you can bet they're thankful to call this place home. Have you ever celebrated Thanksgiving here? If you think you recognize this historic hamlet and its 1802 Congregational Church, turn to page 98 and see if you're correct.

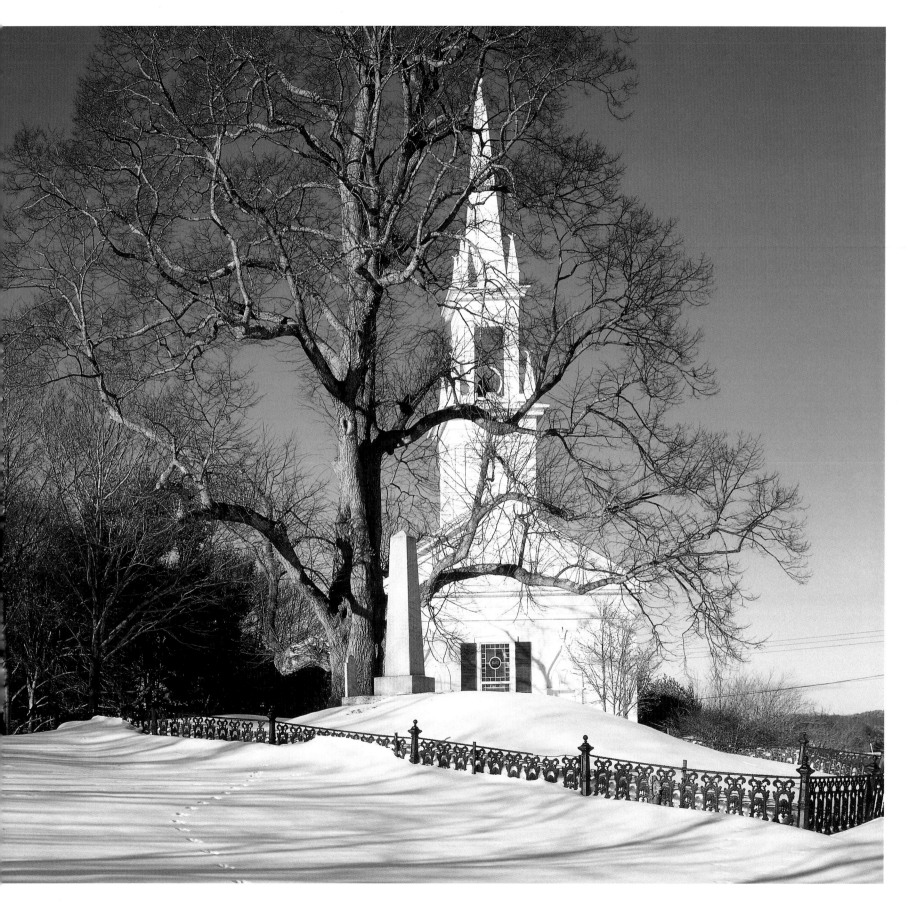

Can you recognize this colorful community?

Vermont might like to think of itself as the foliage capital of New England, but it's lacking one thing only Maine can provide — the glorious contrast of blue-green saltwater. This tidal river in the midcoast, separating two closely entwined communities, is a prime example. It's one of two major Maine rivers flanking a well-known town that is home to five distinct villages. If early settlers had their way, the place would be called New Dartmouth today, or perhaps County Cornwall. But the town got christened after an English duke during the reign of King George II. The area is renowned for its annual run of alewives, its Glidden Middens — oyster shell heaps — and its Catholic church, which is the oldest continuously operated Catholic sanctuary in all of New England. But this time of year its most famous feature is its hotly glowing hardwoods, radiant above river and bay. Turn to page 98 if you recognize this scene.

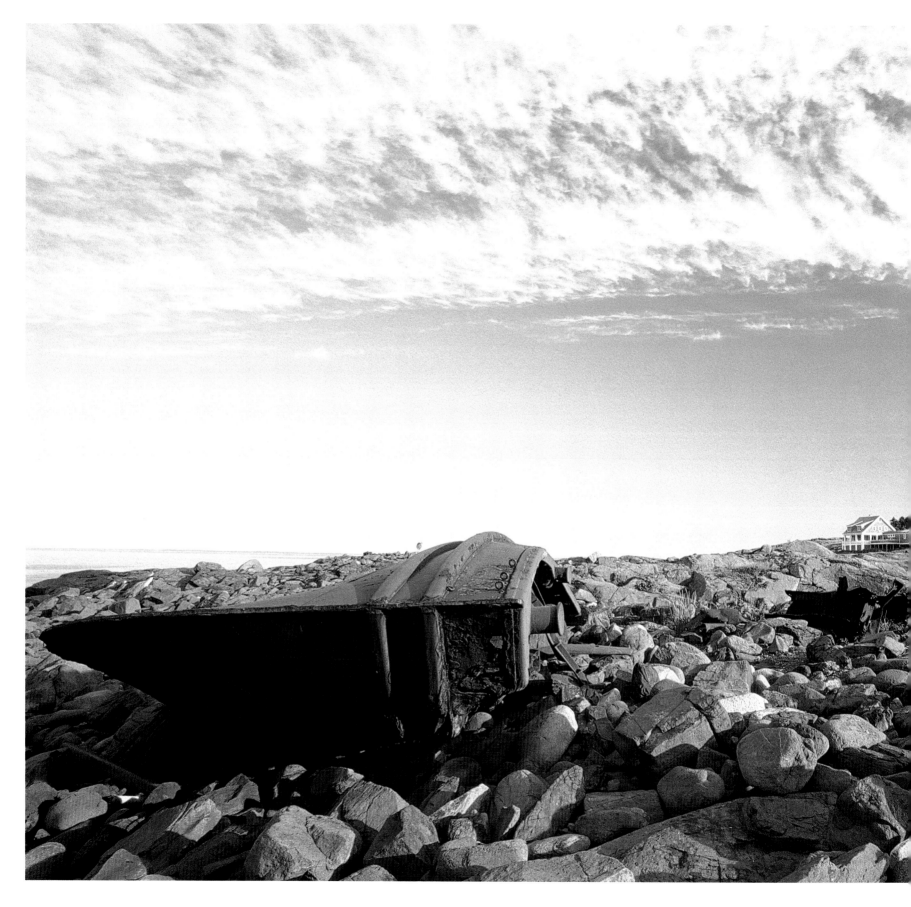

Have you painted the remains of this well-known wreck?

What a nice day for a shipwreck — for visiting a shipwreck that is. This one couldn't be any easier to get to, sitting as it does beside a popular walking trail at a popular midcoast cove. In truth it could be simpler to reach — to explore the monumental, rusting ruins of this old boat, which went aground in dense fog in 1948, you first have to ferry over to the island where it met its fate. (The boat you'd ride docks around the corner from this toothy beach, so don't worry.) The 110-foot tugboat *D.T. Sheridan* lost its way in the murk as it journeyed from Philadelphia to Maine, escorting two coal barges. Rocks tore through its steel hull, but luckily the Coast Guard was able to evacuate the crew and there were no injuries. Sixty years later, the boat lies twisted like a concertina, almost as much a part of the landscape as the cliffs that soar on the other side of the island. Many artists have rendered the craft, including a famous one who lives nearby. (The pretty old place was built by yet another internationally known artist.) A local visitor's guide strongly cautions anyone who might think to venture over the rocks and into the surf here due to a strong undertow and all those big rocks: "No one has been saved who has gone overboard [here]," it states. But that doesn't stop island residents from setting up towels and sunbathing, often in the nude, among the tall beach stones not far from the wreck. To find out its location, see page 98.

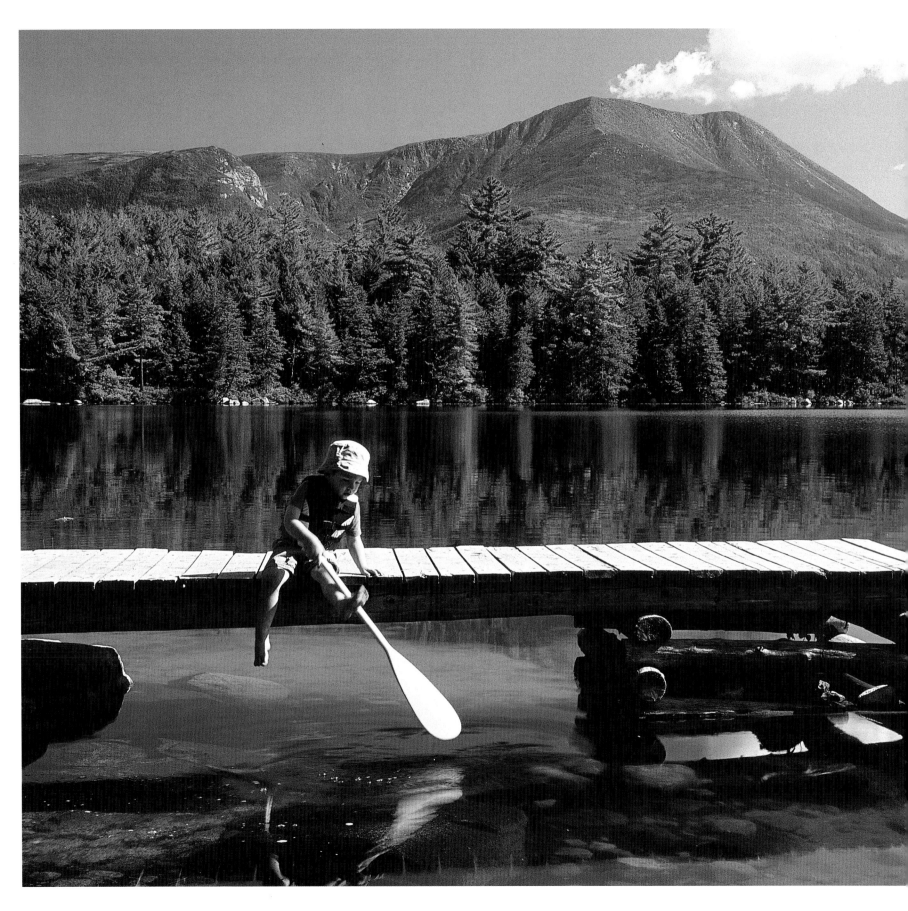

Have you ever visited this part of the park?

Let's make it clear before you even get started that your answer is incorrect. Katahdin, you're saying, plain as blueberry pie. And yes, that is the state's highest peak, the Mountain of the People of Maine, the Greatest Mountain, terminus of the Appalachian Trail. The question, however, is this: What is the beautiful basin that affords this jaw-dropping view? A small pond now within the bounds of Baxter State Park, this place was the site of a turn-of-the-century sporting camp, and a dozen cabins still sit along the shore here. From the porches of several of these, you can look out at the long ridge of Barren Mountain, the rounded crown of the Owl, the deep cut of Witherle Ravine, and Katahdin's magnificent Hunt Spur. Beautiful as the spot is, it hasn't always been serene. Controversy has swirled around the pond in recent years, and the place was much in the news. That's all quieted of late, and today the waters are placid once again. Have you ever visited this part of the park? Turn to page 98 to learn more about this stunning spot.

Can you guess the name of this cunning harbor?

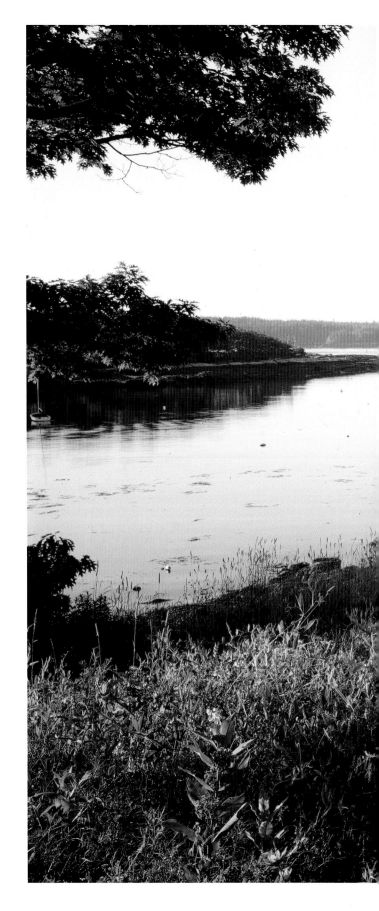

You're thinking, Cutler, perhaps? Or Corea? Some tiny, isolated fishing village Down East? Not even close. Though this harbor — more of an inlet really — has all the hallmarks of a salty hamlet east of Ellsworth, it's actually near the mouth of a wide river that empties into Casco Bay. Reached by one of the many roads that wander pleasantly south from Route 1 in the midcoast, paralleling tidal rivers, quiet marshes, and undisturbed coves, the village hasn't seen the tourist and summer-home development that has spread across its neighboring peninsulas — at least not on the same scale. The boats of lobstermen and deep-sea fishermen outnumber pleasure craft here, though a few fair-weather residents favor the harbor, too. (When she wasn't meeting with President Eisenhower in the White House or staring down Joe McCarthy, Margaret Chase Smith could be found at her summer place on a secluded point in the village.) The name of the harbor is resonant and oddly familiar, but most never find their way here, and those who do know the community often know it from the water — everything is oriented toward the mouth of the river. In this respect it's almost insular, and indeed it technically sits on an island. The acreage that was settled and became this community was purchased from the Natives in 1659 by Colonel Shapleigh of Kittery, and by 1733 the cunning harbor pictured here was settled by the gentleman for whom it's named. It's remained relatively quiet ever since, even though the village is separated from pulsing Route 1 by a mere five miles. But what a difference those miles make. Turn to page 98 to identify this location.

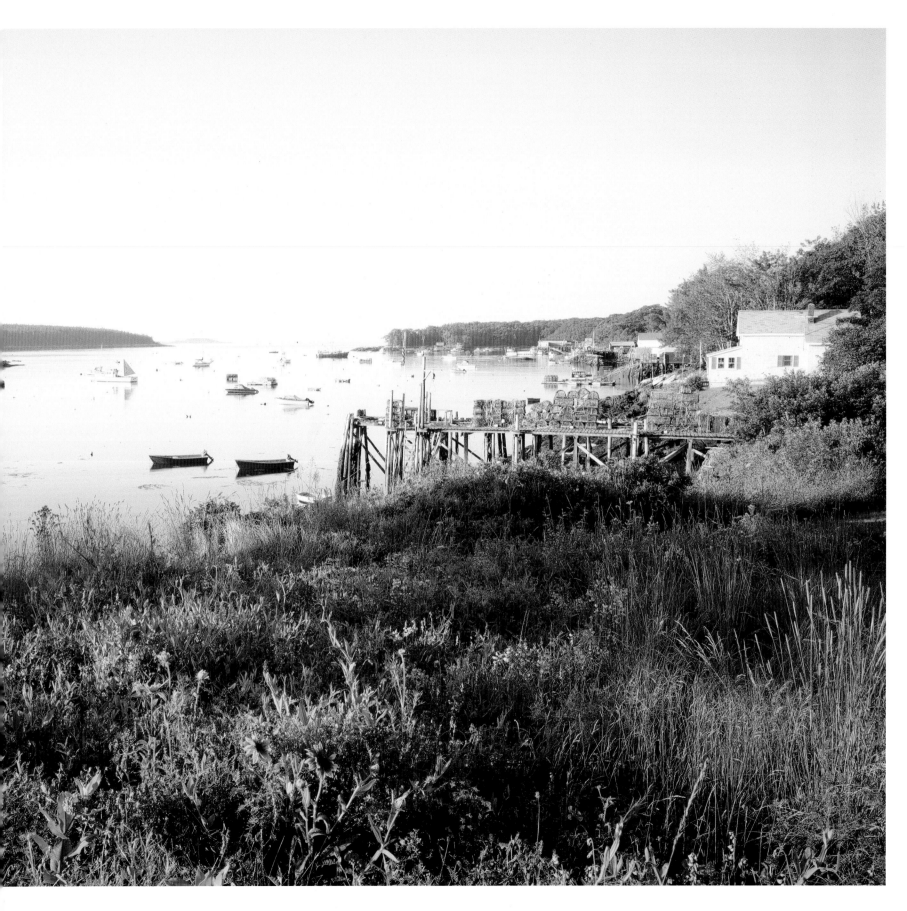

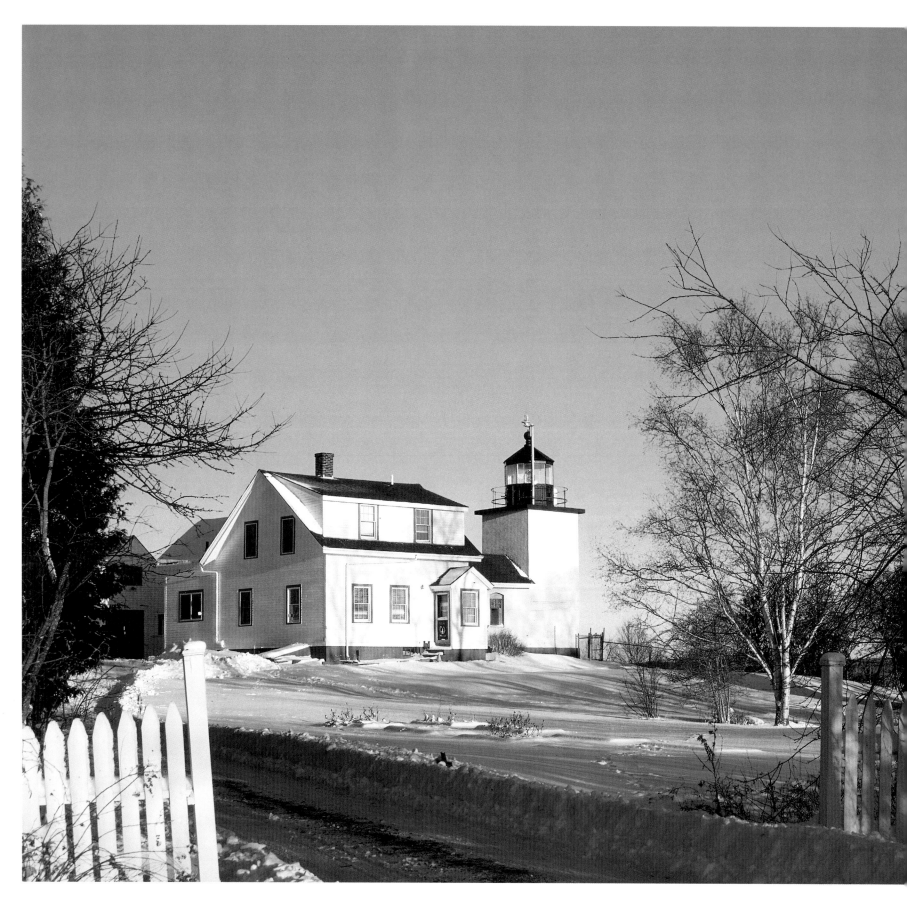

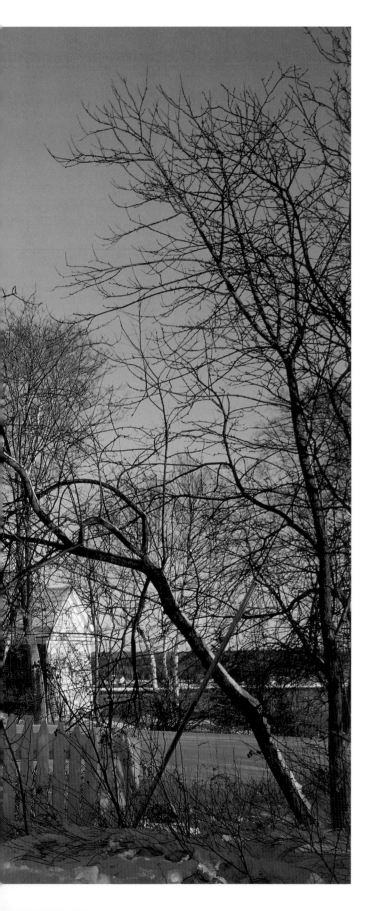

Do you know where to find this coastal park?

This little lighthouse looks out across the "finest bay in North America," if we're to believe the governor of Massachusetts in 1759. Stand on the shore here, with your eyes wide to the bay — said to have an island for every day of the year — and it's hard to argue with the old man who ordered a fort built on this site to protect these important waters from the French and Indians. It was a wise move, since the major river that runs through the region was a fault line of sorts between the English to the west and the French Down East. The same year the fort was being constructed here, Quebec fell to the English, and the French were effectively given the boot from the region. During the Revolutionary War, British troops snuck into the fort in 1775 to remove its guns. Fast forward to the 1880s, and this was a very fashionable spot to be, red coat or no — that's when a hotel was built here in 1872 with the hopes of making the point a rival to bustling Bar Harbor. Well-heeled Bostonians made the trip up by steamboat and stayed in the enormous place, luxuriating amid its running water, gas lights, stables, bowling alley, and dancing pavilions. Unfortunately for the resort, the tony types never found the finest bay in North America as much to their liking as the bays and mountains of Mount Desert. Rather than become a fancy national park visited by millions, this spot turned into a 120-acre state park that all too often gets lost in the great waves of summer tourists that sweep over the region. The square sentinel does its best to attract visitors, but they largely speed by. Those who do visit here know there's some nice fishing to be done on the park's pier, and that there is some exceptional cross-country skiing when the snow's right. Whatever the time of year, the scenery is stunning. Turn to page 98 to see its location.

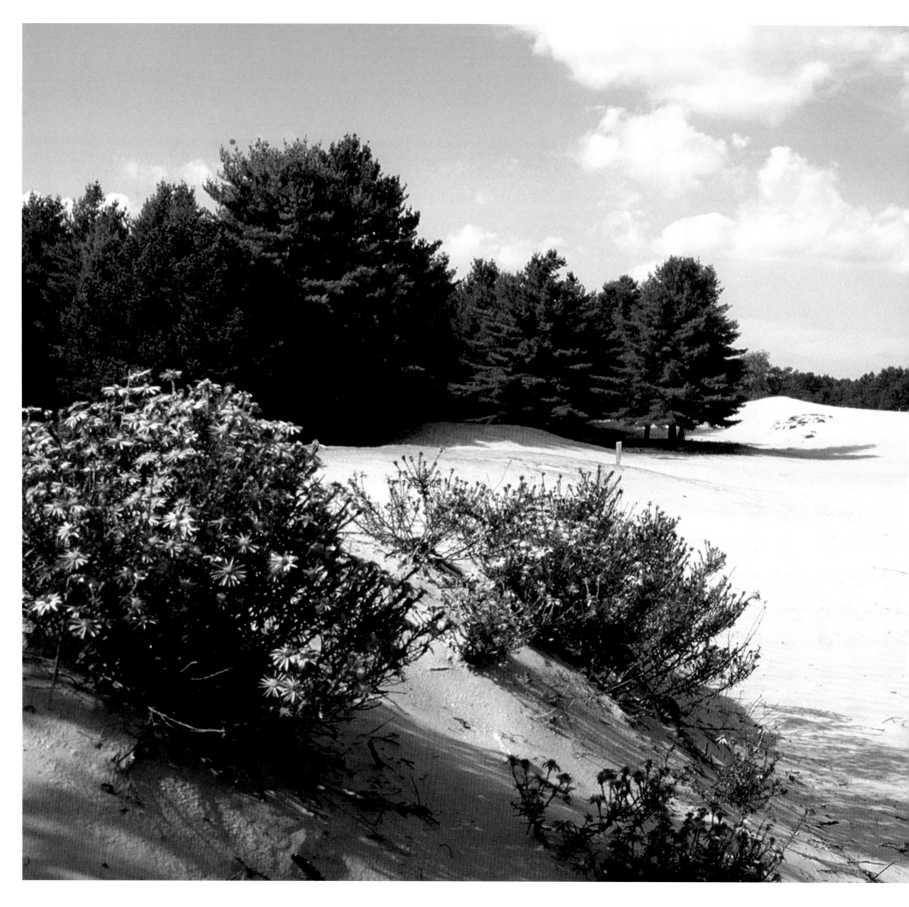

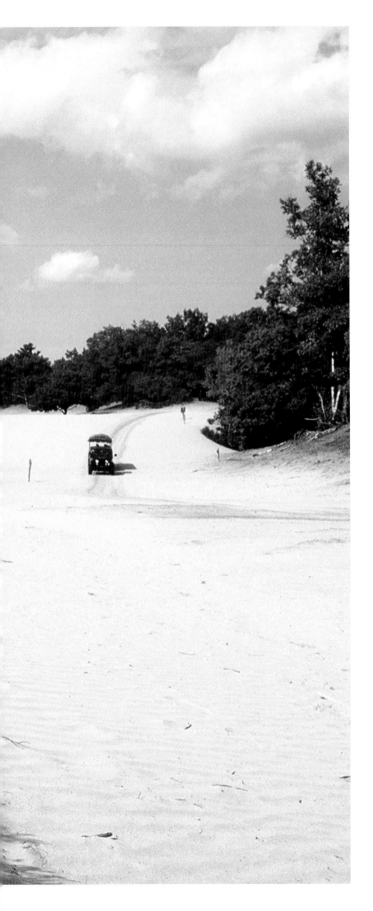

Have you ever visited this sandy site?

Where's the water, you ask? It's an unusual looking beach, to say the least. Maybe it's not a strand at all. These dunes are indeed in a coastal community, not far from Portland. In fact, it may be Maine's most-visited seaside town. Difficult as it may be to believe from the look of things now, the site used to be a 300-acre farm producing potatoes, hay, and herds of oxen and sheep. Centuries ago, the hungry animals unearthed the mineral sea beneath the grasses and the farm fell by the wayside. Some geologists think maybe the whole area here used to be an ancient lake. When the winds howl, sandstorms tear across the dunes and there are trees that are half submerged in sand and still alive. In a state famous for its rockbound coast, this vast expanse of sand is something of a geologic anomaly, and wherever there are oddities there are people who'll pay to look at them. It's no different here. As they have since the thirties, visitors come in droves, paying the entrance fee and enjoying narrated buggy and walking tours through the sands. Nature trails wander throughout the area, a fifty-site campground is adjacent, and there's a picnic area and a souvenir shop where you can buy sand paintings, moccasins, and Maine-made crafts of all types. See page 98 to learn more information about this sandy anomaly.

Can you recognize this mountain resort?

Not many ski areas have views like this. Sel Hannah, the world-famous designer who laid out these runs, even calls this particular skyway "by far the most scenic" of the one thousand trails and three hundred ski areas he's created. And there's no better time to see it than when the hillsides are hung with gold and crimson and the many ponds and lakes in this area at the gateway to the North Woods are reflecting oranges and reds. Beautiful as it is, this resort has always had more potential customers than actual ones. But the owners have a controversial plan to change things. They've been hoping to get the okay from the Land Use Regulation Commission to put in two hundred condominiums, two new hotels and conference centers, an eighteen-hole golf course, a neighborhood of single-family homes, and even a train station. Ideas for putting stuff atop this mountain have been floating around since the nation's first fire tower was installed at the 3,196-foot peak in 1905. Have you ever ascended these slopes? If you think you recognize this mountain resort, turn to page 98.

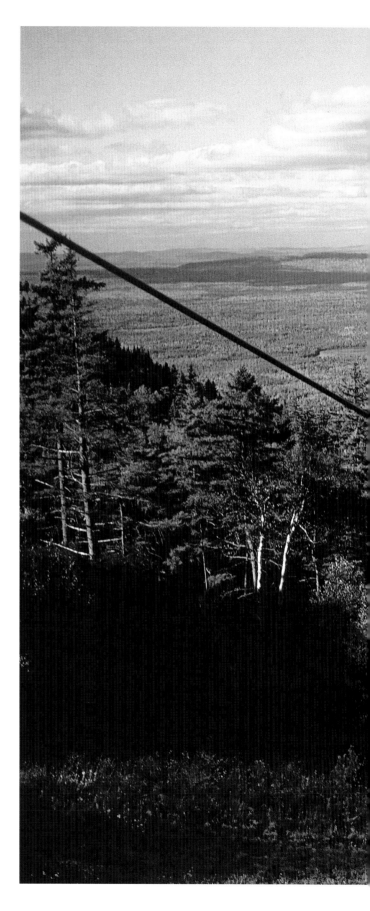

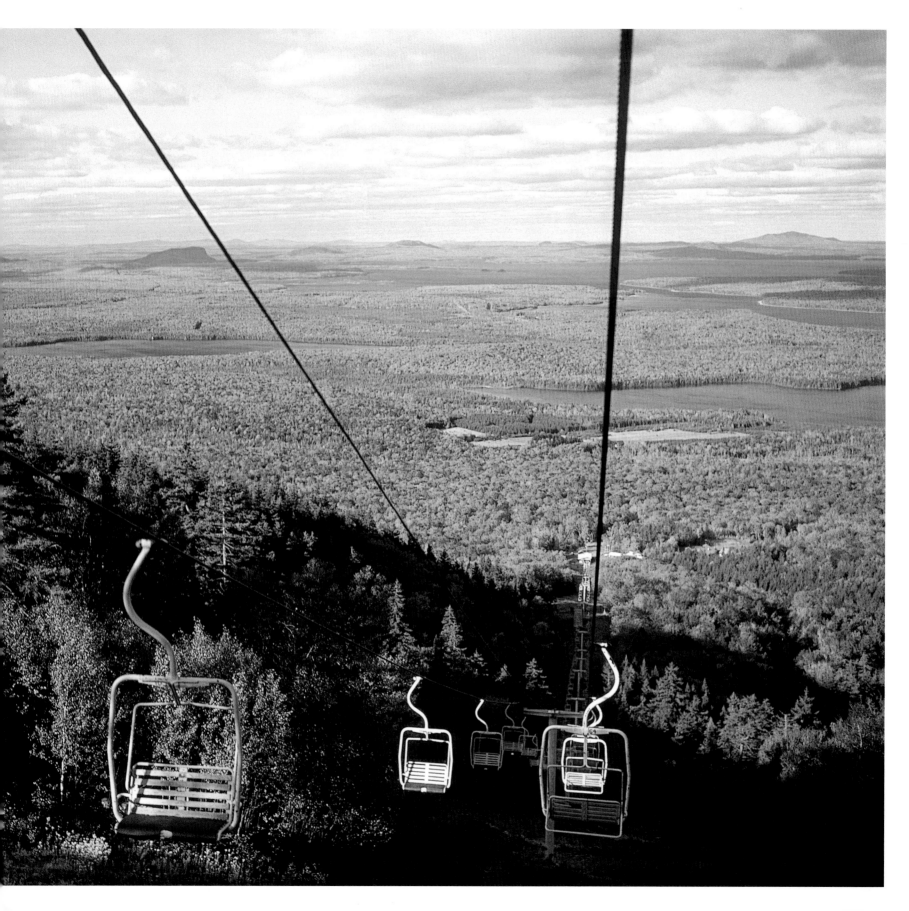

Can you identify this wintry scene?

The waterfront in this midcoast hamlet is quiet under a fresh snowfall. The pleasure boats are long since gone to shrinkwrap, and only a few working boats remain. It's a serene scene in the piney inlet as the holidays approach. Like so many saltwater villages, this one is but a single part of a larger town, and people are often confused just exactly which one, the one to the north, which sounds like it's actually south, or the one below it (whose name might make you think of dragons). And for good reason: the history of all these communities is tightly intertwined. They all used to be a single town of epic proportions, until 1848 when they split. The ink had hardly dried on the maps of these new towns when a bunch of residents in this village wanted to secede yet again and form their own town, aptly called Independence. That didn't work. So they raised the issue again in 1853, and again in 1856, when they thought the town name Melrose had a nice ring to it. This particular village has been called all sorts of things, from Seal Harbor Island to Lobster Cove Island to Elwell's, and then by the early nineteenth century it took its current moniker. Turn to page 98 if you think you know its current name.

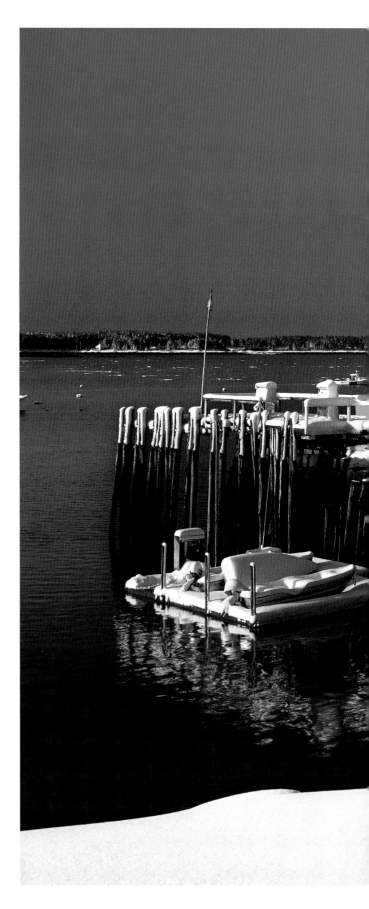

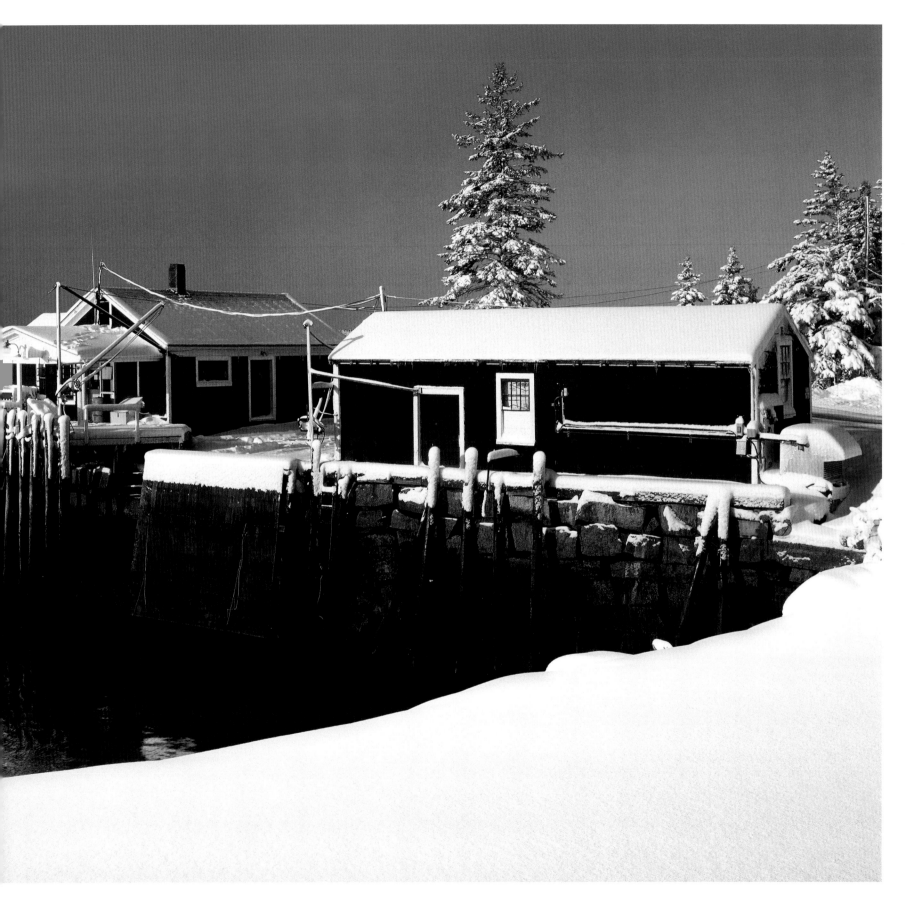

Do you know the name of this central Maine mill town?

It's very clear from this autumnal photograph that Milburn is a mill town. Milburn? That's the name this county seat used before it decided to assume the Abenaki name for "place to fish." The surging Kennebec, which wraps its arms around the little island pictured here, provided the power for grist- and saw- and woolen mills in years past. The 12 $^1/_2$ acre isle is literally the heart of town, and its steep sides posed many problems for Benedict Arnold and his men during their Revolutionary march to Quebec — they had to heave their bateaux over its steep walls to get upriver. Many years later, in 1920, the rectangular building in the center of the image was built as a power station, its inners generating 16,000 horsepower in its heyday under Central Maine Power. Today, though, the central Maine town of ten thousand that grew up around the river is not known so much for electricity as for paper — it shares a mill with the burgh immediately to the south, the border running right through the factory's compound. The municipality is also home to one of the largest of the state's fairs, a massive agricultural festival claiming to be the oldest annual fair of its kind in the nation, and also the country's tallest cigar-store Indian. A sixty-foot wooden sculpture, it was created by an artist affiliated with the respected school of art named after the town. It's also where the HBO movie of Richard Russo's excellent *Empire Falls* was shot. To learn more about this central Maine mill town, see page 99.

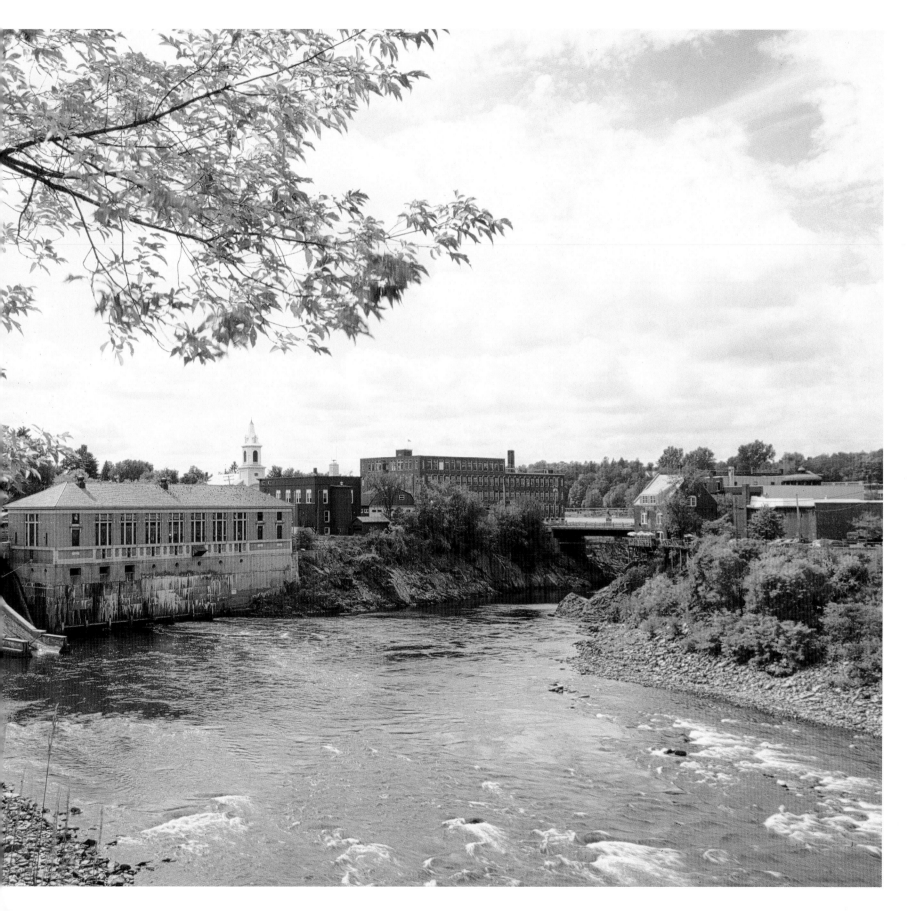

Have you ever spent a day or weekend at this scenic spot?

A June day at this central Maine state park looks so inviting that you want to swim all the way to the mountains in the distance. Better to wait until a lifeguard is on duty, though, and the cool waters warm a bit. This photograph doesn't lie — the lake is a picture-perfect one, located about ten miles from the geographical center of Maine. Established in 1969, the park was a gift from a wealthy attorney — it bears his name and that of his sister — and it deserves to be busier than it is. In a typical year, only about 25,000 people put their toes in here, picnicked nearby, or camped in the fifty-six sites spread out across its 839 acres. Compare that to Sebago Lake State Park, which saw more than 202,000 visitors, or Camden Hills State Park, which was visited by almost 140,000. But as this image attests, this park is a special place, and those who have never stopped by are missing out. Have you ever enjoyed a day or weekend at this scenic spot? Turn to page 99 to learn more about this little-known gem.

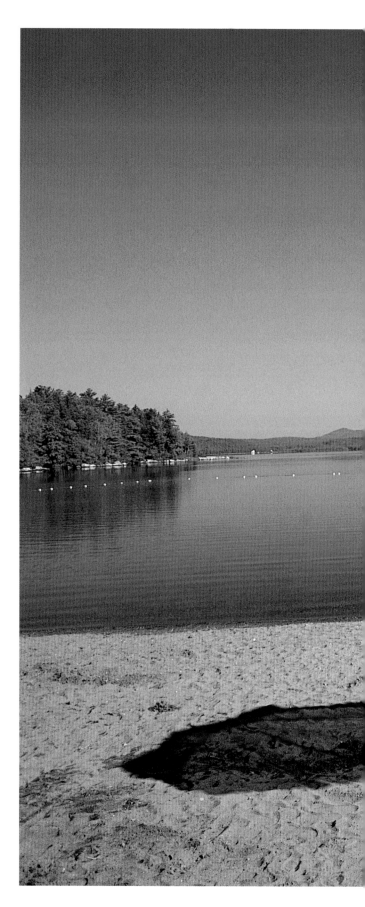

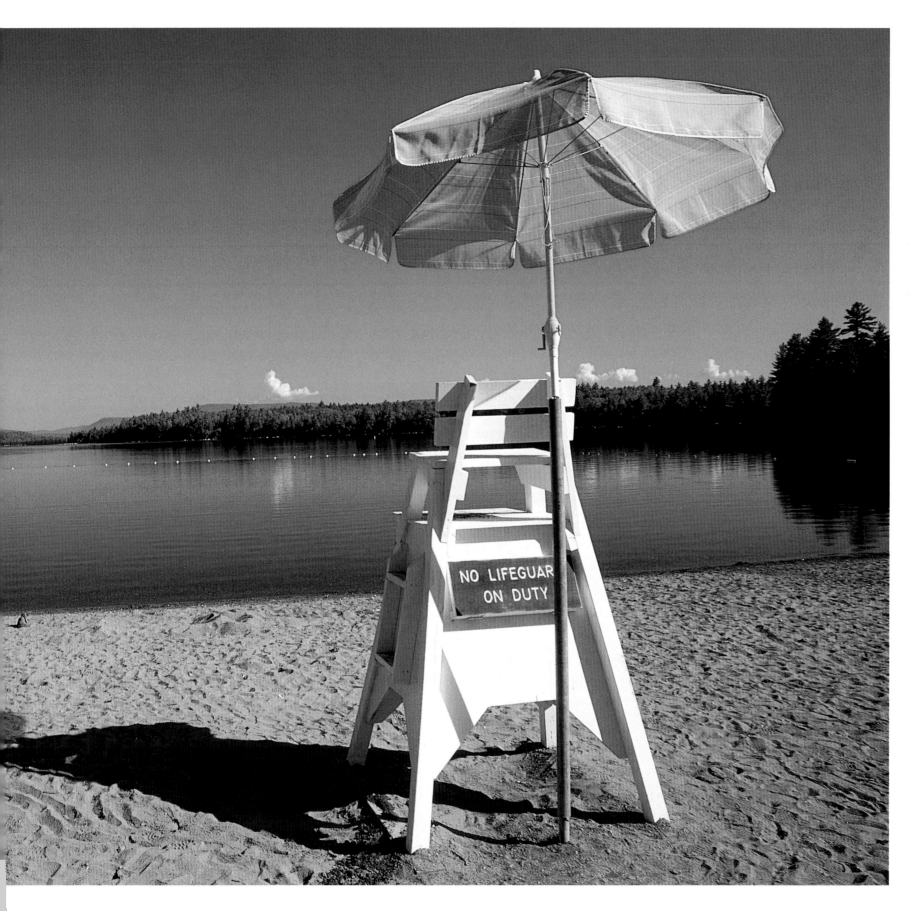

Do you recognize this hill named for a Roman god?

Aroostook County is about as flat as Maine gets. The County may be big — and boy is it big — but it's not very tall. The state's northernmost county is larger than the states of Connecticut and Rhode Island — combined. But the whole is about as hilly as the pancakelike ployes for which the Saint John Valley is famous. This here eminence, all 1,700 feet of it, is as lofty as lofty gets in Aroostook, rising straight up from a level plain. The hill sits on the border with Canada, lording over the Saint John River Valley, and the first settlers to the area were lured from New Brunswick by the promise of prosperous farming. The name of the local community comes from Greece via a British army chaplain, who held a service at the summit in 1790 and commented that the hill looked like the one in Athens dedicated to a Roman god. This geomorphic buckle factored heavily into geopolitics in the early days of the United States. It was integral to a boundary dispute between the young country and the Brits that dated back to the Treaty of Paris 1783 and almost led to bloodshed in what was called the Aroostook War. More recent controversies (we're talking in the early 2000s) occurred when a Maine-based developer announced intentions to locate twenty-eight turbines on the side of the hill to make Maine's first wind farm. These 389-foot windmills would create enough power to electrify 25,000 homes — many more than can be found in this town of 1,488. And unlike the Brits, these outsiders won — the turbines were constructed in 2006 and today this mini mount looks much different. See page 99.

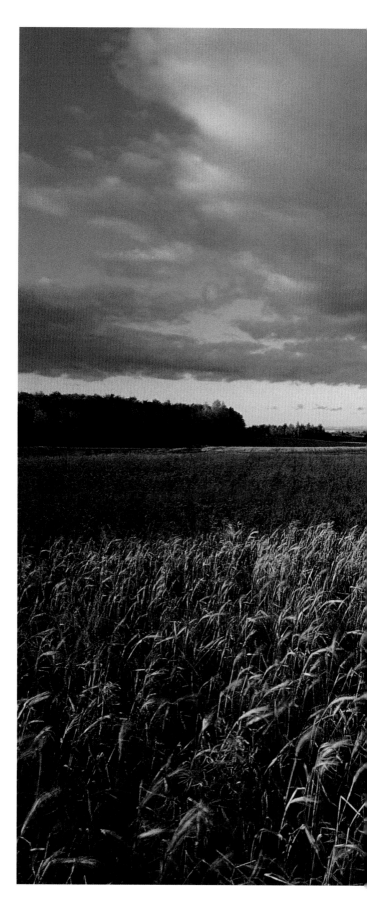

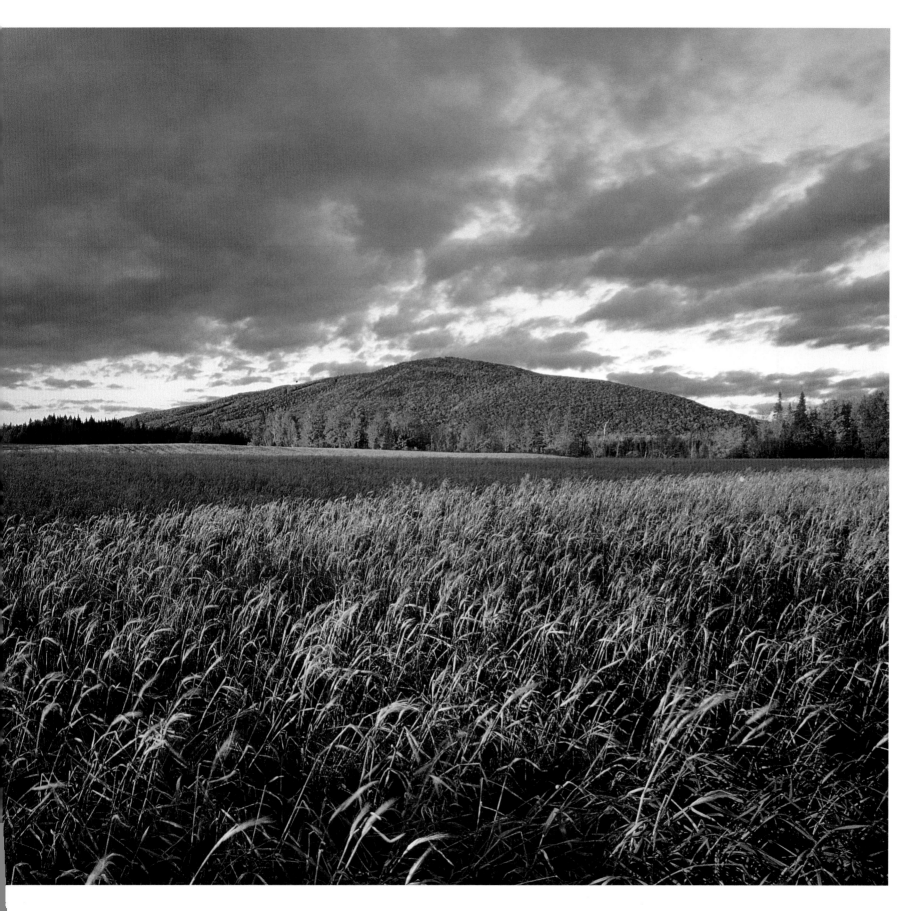

Ever given this precarious boulder a good shove?

Don't mess with a glacier. That might be the story that this rock star would tell if it could talk. During the Ice Age, a sluggish sheet of ice and snow dragged the boulder some forty miles from its home before depositing it in a precarious position, balanced on a ledge halfway up a famous hill Down East. (According to local lore, the granite it's made of is of a type that can only be found in Lucerne, a village south of Bangor, so everyone supposes that's where it originated.) In the years since the ice melted, the plucky boulder has become a tourist attraction simply by sitting here and defying gravity. From the road below it seems certain to fall, and soon. (It also seems smaller than it is — a geology professor at UMaine has called it "about the size of my two-car garage.") But it isn't going anywhere. A bulldozer has tried to unseat it, as has an entire high-school football team, both to no avail. During the forties, after a local tragedy that made national headlines, a group decided it was best to remove the glacial erratic before it fell on someone's head. Thus the bulldozer. The football team came later, and many others have hiked up the hill to give the rock a heave. Lucky for these self-appointed Sisyphuses the stone has a very pretty view — at least in their defeat they've had something to look at. Another green mound, much like the one on which the rock sits, lies nearby and beyond it, mountains and sea stretch in a paisley pattern off into the horizon. Turn to page 99 to learn more about this dramatic perch.

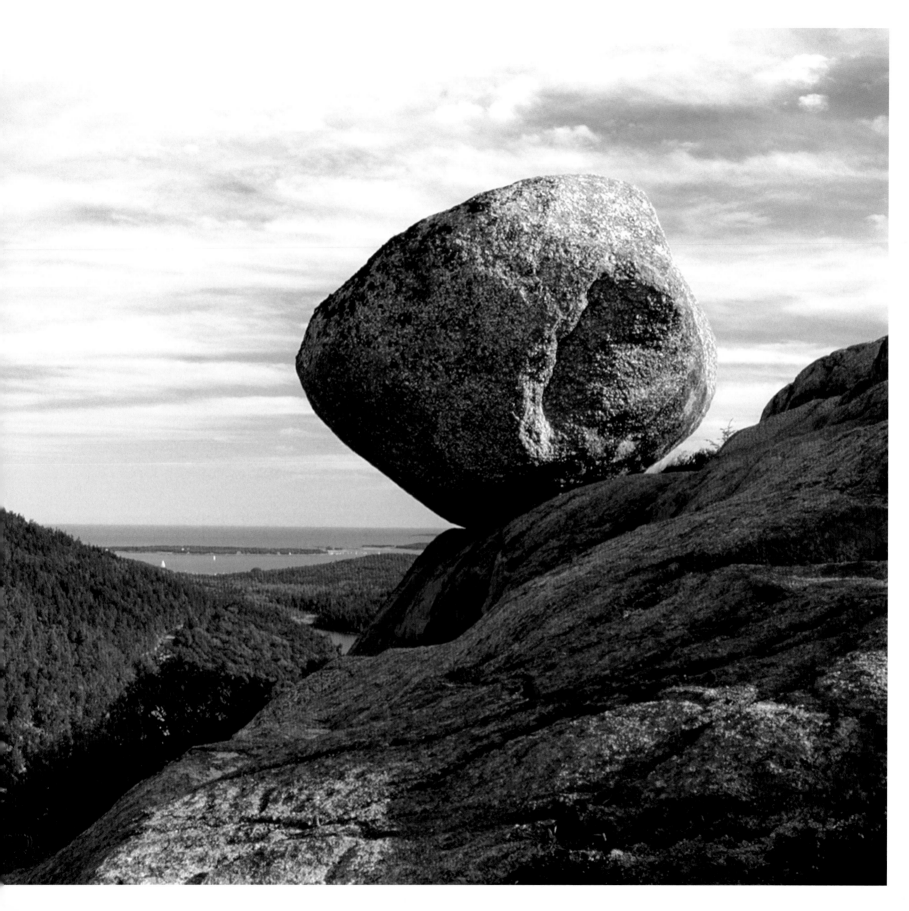

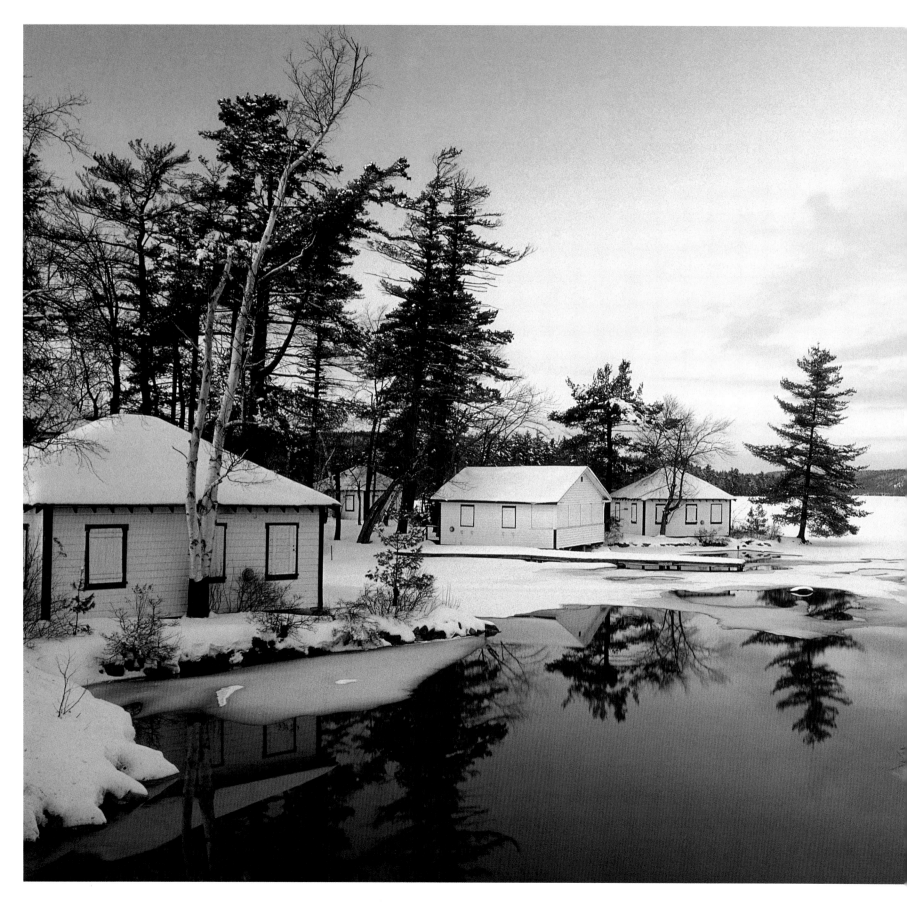

Have you bunked in these cozy cabins?

When the snow settles gently on this central Maine village, the population drops to about half of what it is during the summer. Maybe even less than that. Sporting camps like these make little boarded-up ghost villages, and the fishermen who come to troll for salmon are probably dropping lines for tarpon somewhere sunny. The family camps on the shore of this long lake are likewise closed for the season, and tourists disappear like Judge Crater, the New York Supreme Court associate justice who had a summer home around here and mysteriously vanished one day in the 1930s, becoming one of the biggest unsolved mysteries in U.S. history. These twelve camps are on a tiny island surrounded by communities with European names, underneath the shadow of "The Mountain" and just around the corner from Elizabeth Arden Road. They were constructed in the late 1920s by a local gentleman who actually built the island on which they sit, hand-filling an acre of water. Finding guests to fill the camps was never a problem. People have been summering in this area since before the turn of the century. A 1981 movie, set here but filmed in New Hampshire, introduced the nation to this land of lakes. Nowadays, kayak and canoe outfitters do a brisk business here, and in more recent years a golf course opened that has been rated one of "America's Greatest Public Courses" by *Golf Digest* and continues to draw big crowds. Just not in January. See page 99 to learn the location of this wintry scene.

Can you identify this peaceful oasis?

People often think that they have to visit this lovely coastal garden during late May and early June, when its signature flowers are in bloom. But the garden is such a stunning little anomaly it's worth stopping by whenever it's open. Not only is this Japanese-inspired oasis located on a Maine island, it's widely considered one of the best in the nation — ranked eleventh in a survey of Japanese gardens in North America. Here you'll find pretty pathways that wander beside reflecting pools and along a stream, little antique lanterns, stone bridges, and benches for quiet contemplation. The garden was originally built in the late fifties to rescue trees and flowers in danger of being destroyed. The transplanter was given a year to move the substantial collection of prized plants — which he did, installing them in what had been an alder patch across from a historic inn. The garden has undergone many transformations over the years, but it has always ranked among the state's finest. Stop by during daylight hours from May 1 through October. If you think you know the location of this Far East oasis, turn to page 99.

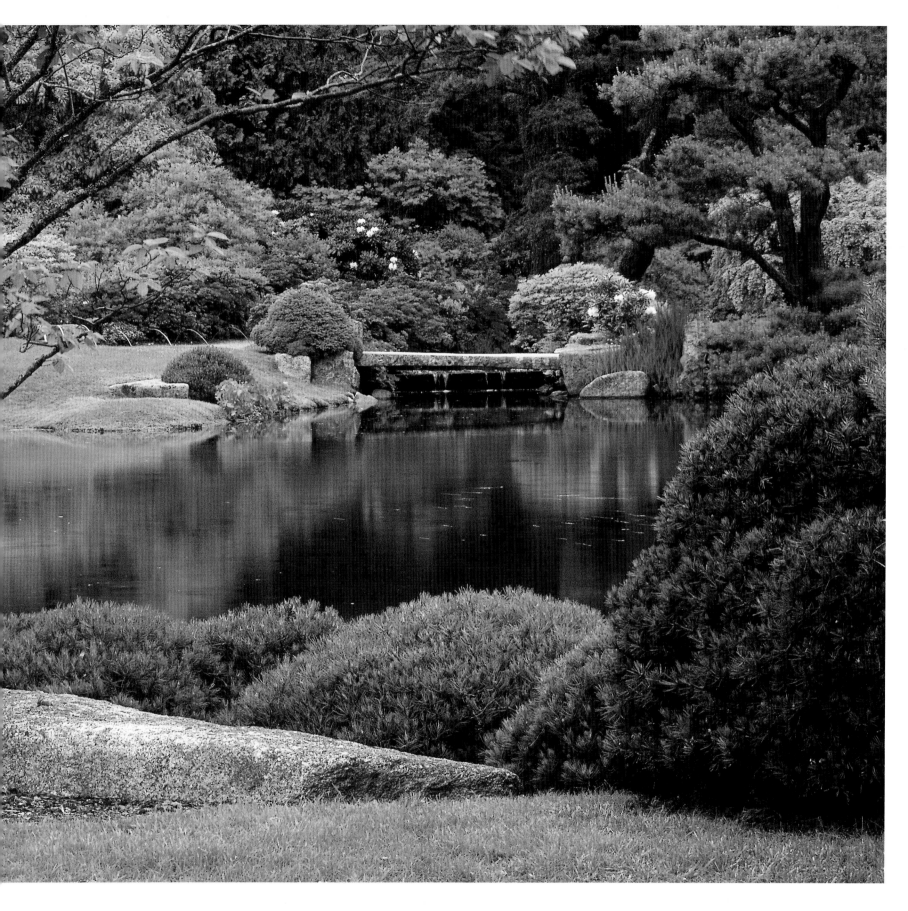

Can you identify this snowy scene?

Views like this are not easy to find in southern Maine anymore. A weathered dock, a graying boathouse, a curve of undeveloped shoreline — this scene looks much the way it might have fifty years ago. The same can't be said about this particular community, now synonymous with shopping and trading. In fact, open space is at a premium in this, the oldest incorporated town in Maine, which is why conservationists are working hard to preserve what remains. The local land trust got some good news recently, when a generous resident helped it acquire sixteen acres of prime real estate along this saltwater stream — at two thousand feet long, it's the longest undeveloped riverside property in town. You'll have to drive around the notorious tangle of streets to find it, but lots of people do, searching for one of the best lobster shacks in Maine (in the judgment of *Travel & Leisure* magazine and others). Here's a hint: the popular seafood restaurant is named after this tidal waterway. Turn to page 99 to identify this snowy scene.

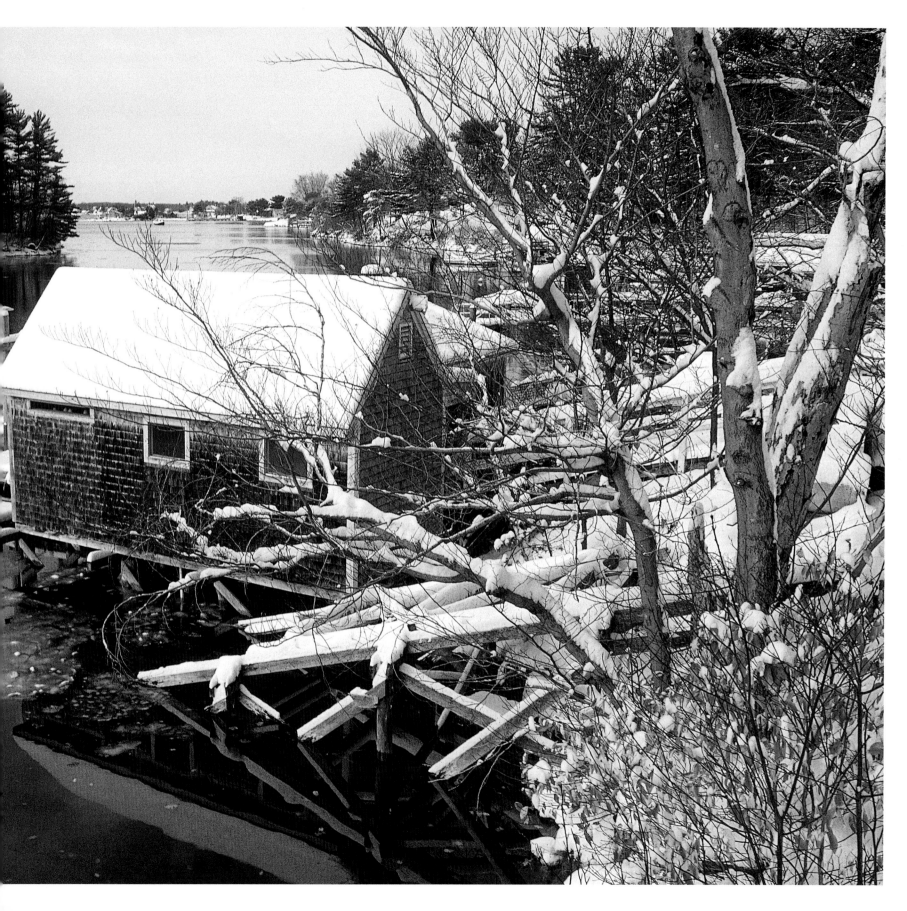

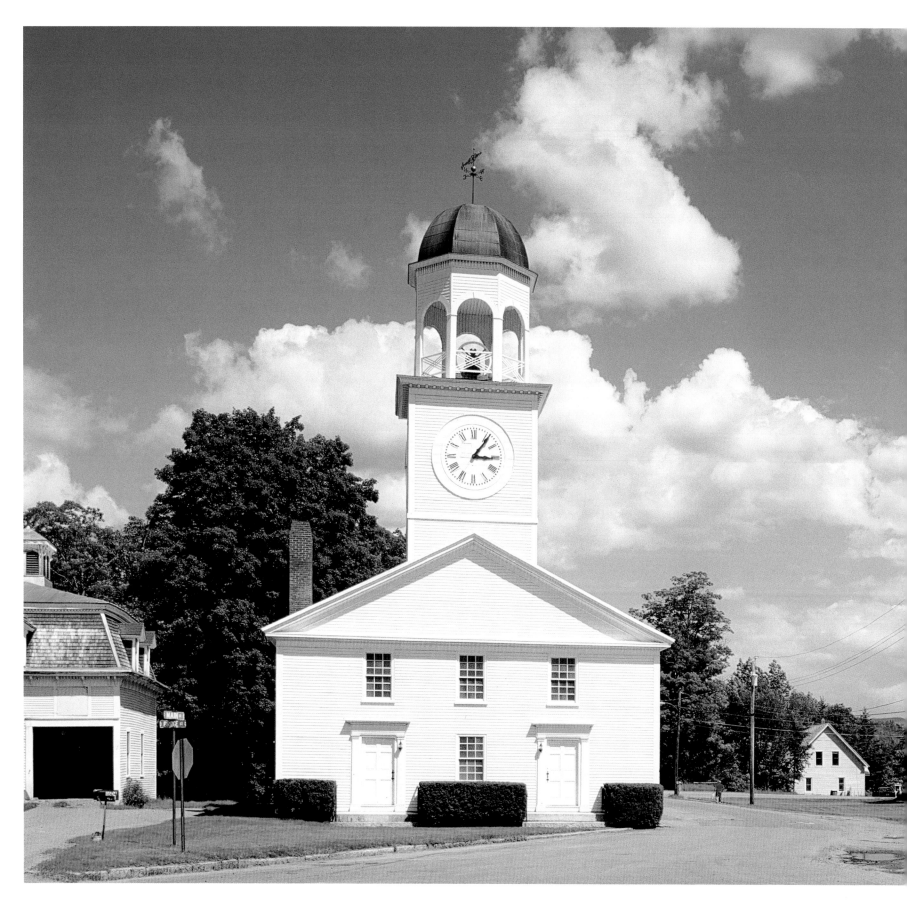

Have you seen this church in the woods?

This graceful church has witnessed its share of drama. The Congregational meetinghouse sits across from the local historical society's headquarters at the head of Main Street in this western mountain community of roughly 2,000, and it's been home to the usual fiery sermons, somber funerals, and jubilant weddings. But it's also seen four major fires tear through town in the span of a hundred years, the most devastating — one that singed the face of the church — taking place in 1971. Both the church and the community recovered, and a couple decades later, the old house of worship finally received the clock it had been waiting for since 1835, when the bell tower was built with circular openings where a clock should be. The town figured it would be able to install a proper timepiece a few years down the line as the community grew and prospered. Beautiful and pleasant though it may be — sitting astride a well-known river in the shadow of well-known mountains — the town never did get to the point where it could complete the project. But after more than 150 years of looking at the blank steeple, townspeople decided the time had come to rectify the situation. In 1991, after a year of bake sales and bean suppers, T-shirts sales and Monte Carlo nights, a classic 700-pound Seth Thomas clock was installed, adding a bit of temporal order to Main Street. One observer called the mighty fund-raising effort "perhaps the biggest thing that ever hit the town." (Actually, the biggest thing would probably be the fire of 1971.) The church has certainly seen a lot. Maybe you've seen the church? Check page 99.

Have you ever strolled this sand?

The obvious question is: Where are all the people? It's rare that this stretch of coastline is so quiet that there isn't someone enjoying the sands. There's almost always a beach stroller, shell seeker, sandcastle builder, or sunbather on this, one of the state's most popular beaches. That's the way it's been here since the Pilgrims were splashing in the surf to the south — even longer, according to local historians. Englishmen first stepped ashore on this curve of the midcoast in 1607, more than a decade before the founding of the Plymouth Bay Colony, and the same year as the settlement of Jamestown. Of course, they were gone months later, after erecting a small fort, a church, and some fifty houses. They also built the first boat ever constructed in what would become Maine — the fifty-foot pinnace *Virginia*. But they found winter Down East just wasn't for them – so they abandoned fame, fortune, and future reenactment villages to the Jamestownians and the *Mayflower* Pilgrims and left everything else to archaeologists. In recent years, local partisans have made the case that the first Thanksgiving in the New World was enjoyed right here, but the people of Plymouth, Massachusetts, with their rock and their cute costumes, didn't buy it. The only pilgrims the beach sees now are the summer-loving, sun-worshipping kind. And boy, do they come — some 180,000 visit each year. The 529-acre site is famous for its dunes, its cold waters, its rivers, and undertows — and its difficult parking. Striped bass fishermen flock here as well, and movie stars like Paul Newman and Kevin Costner once spent a few days in the vicinity. With the 3,640-foot expanse of sand, the islands offshore, the surf crashing, the boats passing by, it's not hard to understand the appeal. See page 99 to learn more about this sandy spot.

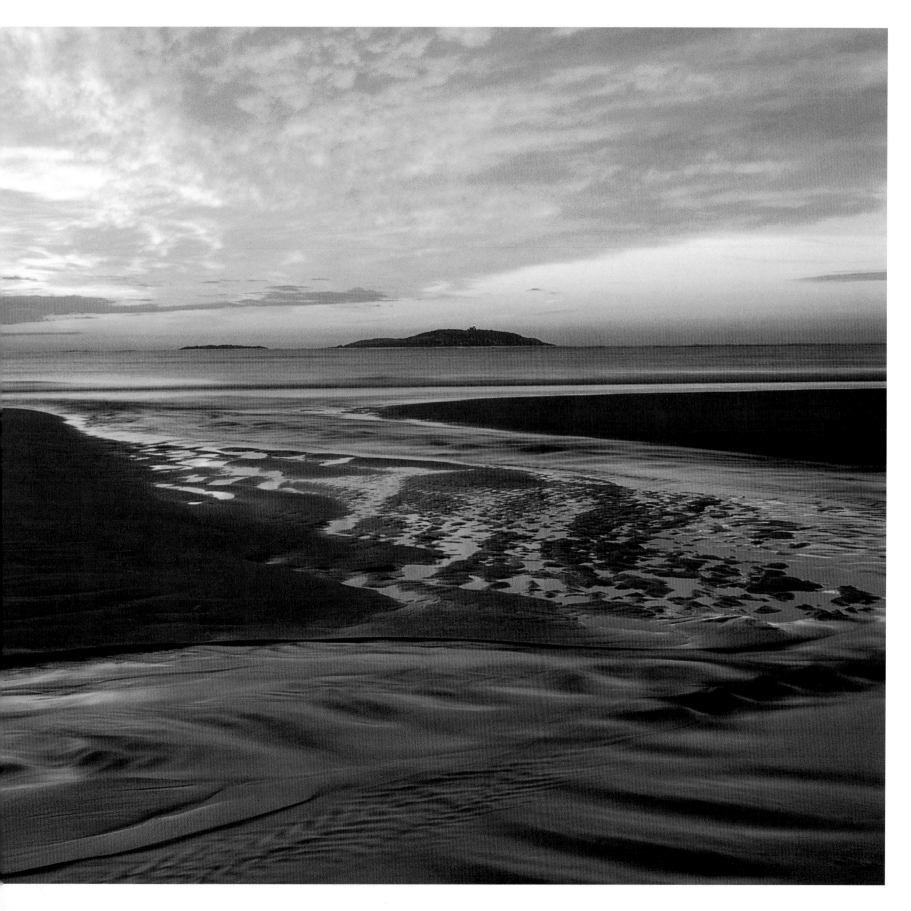

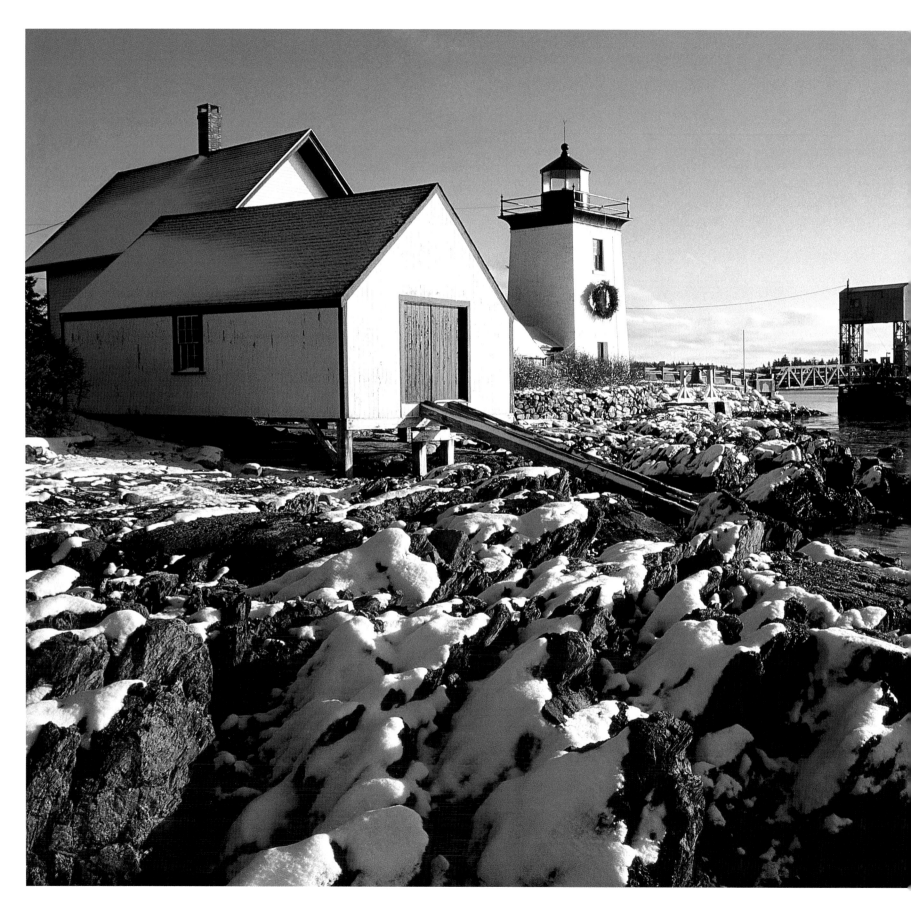

Have you ever hopped the ferry to this island?

Ah, the holidays on Long Island. That's the former name of this lengthy isle in the middle of the state's coast, and it couldn't be any more apt — the skinny island splits one of Maine's largest bays in half, stretching for ten miles. The ferry taking islanders three miles across the water to the mainland looks cold this time of year, even under the sunniest of skies. The village not far from this landing has been home to an exclusive summer colony since it was "discovered" by Jeffrey Brackett, a trend-setting Bostonian, in 1889. He was followed by the likes of J.P. Morgan and some of the biggest names in American industry. In more recent years Hollywood has found it. You don't have to be one of the Hardy Boys to figure out what Cheers the rich and famous about the place: She's So Lovely. The year-round residents (who number six hundred, according to the most recent census) tend to go about their business and leave the celebrities alone, building boats, working carpentry, or commuting to jobs on the mainland, boarding the ferry in the shadow of this square brick tower. The lighthouse was ordered built by President Franklin Pierce in 1851, and it was redone under command of Ulysses S. Grant in 1874, which was about the time the largest shipping fleet in the bay was working out of the island's harbors. At the lightkeeper's house is a small museum where you can learn about this sort of thing — in the summertime, of course. For now you'll just have to content yourself with the views. To learn more about this festive island, turn to page 99.

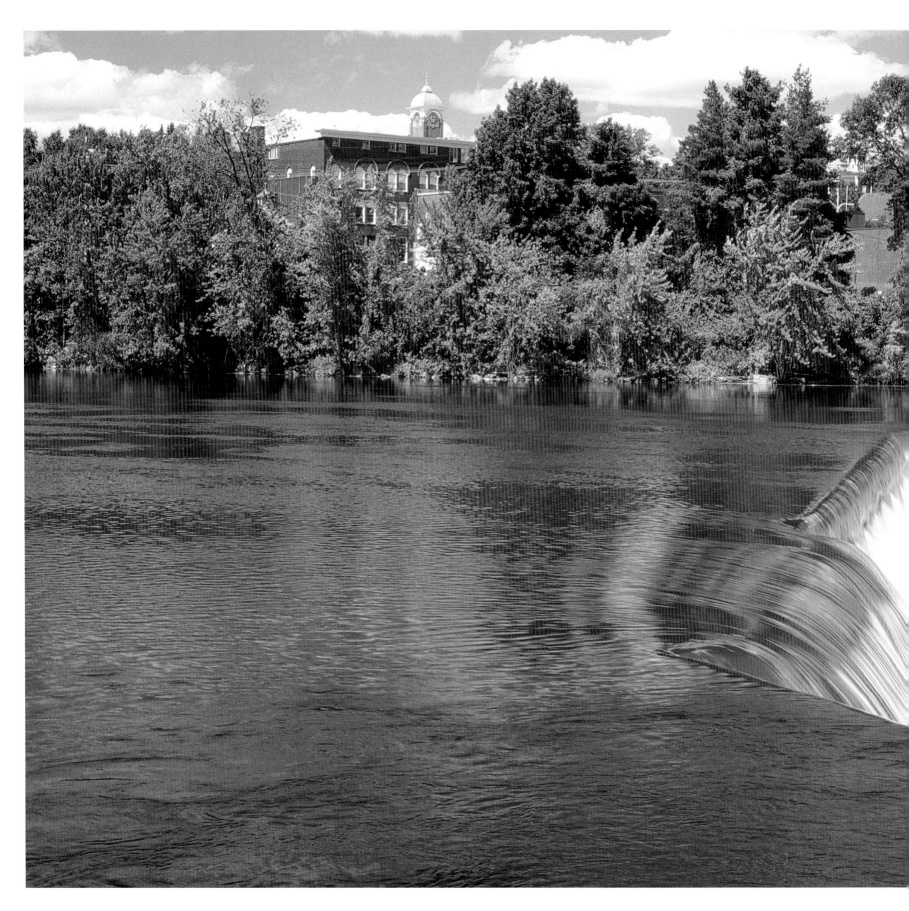

Have you motored through this historic mill town?

Without the man this mill town was named for, honest Abe Lincoln would have been minus a vice president. The Civil War-era second in command, Hannibal Hamlin, was the grandson of that early settler, and the veep's father was the first physician in this riverside community. Hamlin is the most prominent politician associated with the central Maine burgh, but there were many others, from U.S. congressmen to governors. One local family alone produced four Republicans with national profiles. (Of course, the famous folks who once lived here weren't all politicos — the inaugural graduate of Colby College spent his formative years in town, as did the Civil War hero who lent his name to Howard University in our nation's capital.) Even the irascible Samuel Adams had something to do with the goings on here — he was governor of Massachusetts in 1795 when the little municipality was incorporated and he gave it his blessing. Like Adams, the first people to put down roots hereabouts were from greater Boston, and they brought with them farming traditions they learned in the Bay State. Apples were once an important crop, and cheese was also a big seller. When the Industrial Revolution hit, the town — like several others on the same river — turned to papermaking, but the mill closed years back. These days, the community is best known for a venerable, open-air museum of sorts — you might even say history lives here. Have you motored through on your way to the western mountains? Turn to page 99 to find out more about it.

Have you seen the view from this island?

Behold the birthplace of Maine as we know it. Well, that's what some people say. Many historians think these island outposts are where the first Europeans set up camp Down East, establishing the famous Maine fishing economy long before Chris Columbus ever made his little sailing expedition. Some scratches on a cliff face on the island across the harbor are thought to be evidence of a visit by Vikings about 1000 A.D. There wasn't much to plunder and pillage here then, but the fishing grounds were world class — the Norsemen must have thought they'd died and gone to Valhalla when they got a load of the local cod. Fishermen from Portugal and Spain were likewise amazed by the seafood, which all but hopped into their boats, and some think they built fishing camps here before 1492, too. Of course, indigenous tribes were here long before that and the island in the foreground has a Micmac moniker. The big grassy rock in the background has a very unusual name for these parts (not to be confused with an island of the same name off Oahu). That island was never settled in any sort of numbers, though it did see some dwellings. The tramway seen in the picture was put in place by the Coast Guard to haul supplies to a fog whistle with national significance — it's the only one housed in its own tower. No one heard the signal blow more often than Raymond Phillips, who lived in a small shack on the island all by himself from the 1920s to the late seventies. A former food scientist from New York with a degree from NYU, he left the city behind to become one of New England's most famous hermits, preferring the simple life of a shepherd. Who can blame him, with this kind of view? Turn to page 100 to learn the name of this island.

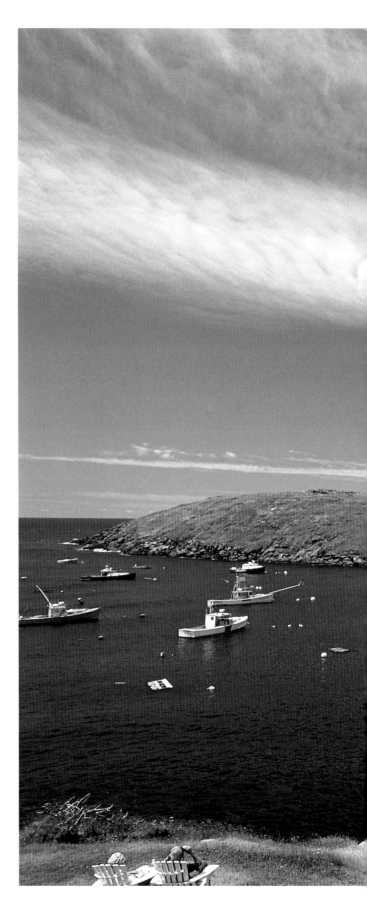

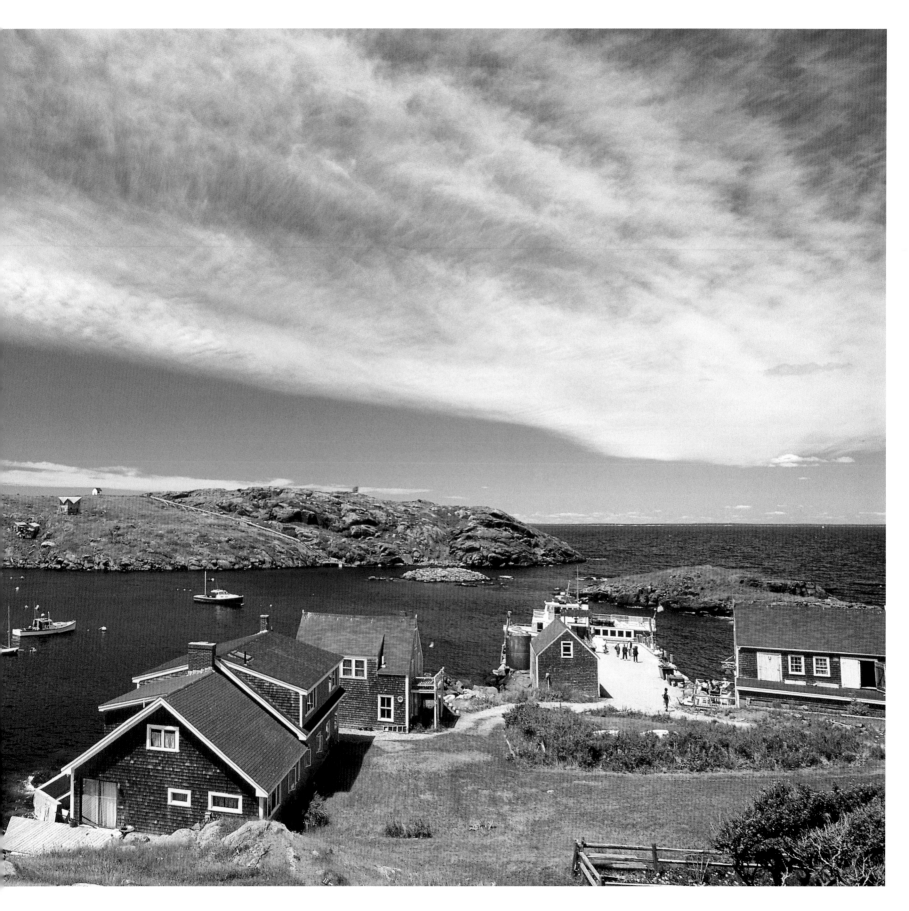

Do you recognize this hushed hall?

With the colonnade of ash trees beginning to leaf out in the late spring sun, going to the mall is especially inviting on a June afternoon. The freshly mown lawn is but one of the many clues in this verdant scene. The flag pole in front of the imposing brick edifice is something of a giveaway, suggesting an institution of some sort, a public building. The multiple entrances and inviting steps further that idea. Could it be a town hall, perhaps? Maybe a venerable high school or post office or museum? Possibly a barracks even? It's too pleasant-looking to be prison-related. Well, here's what we know: Construction of this impressive structure began in 1941, but it was postponed because of the Second World War and completed in 1947. Funding was provided by a prominent businessman who donated a great deal of money in the area. The population of the town hereabouts is just over 9,000 in the summer, and the community, named for a Penobscot Indian chief, is known for the pretty National Register homes in its historic district — testaments to the importance of timber in the region — in addition to the goings on in and around this particular building. On warm days, people appear here like dandelions in springtime, enjoying the sun or playing Frisbee on these green grounds. See page 100 if you'd like to educate yourself about this location.

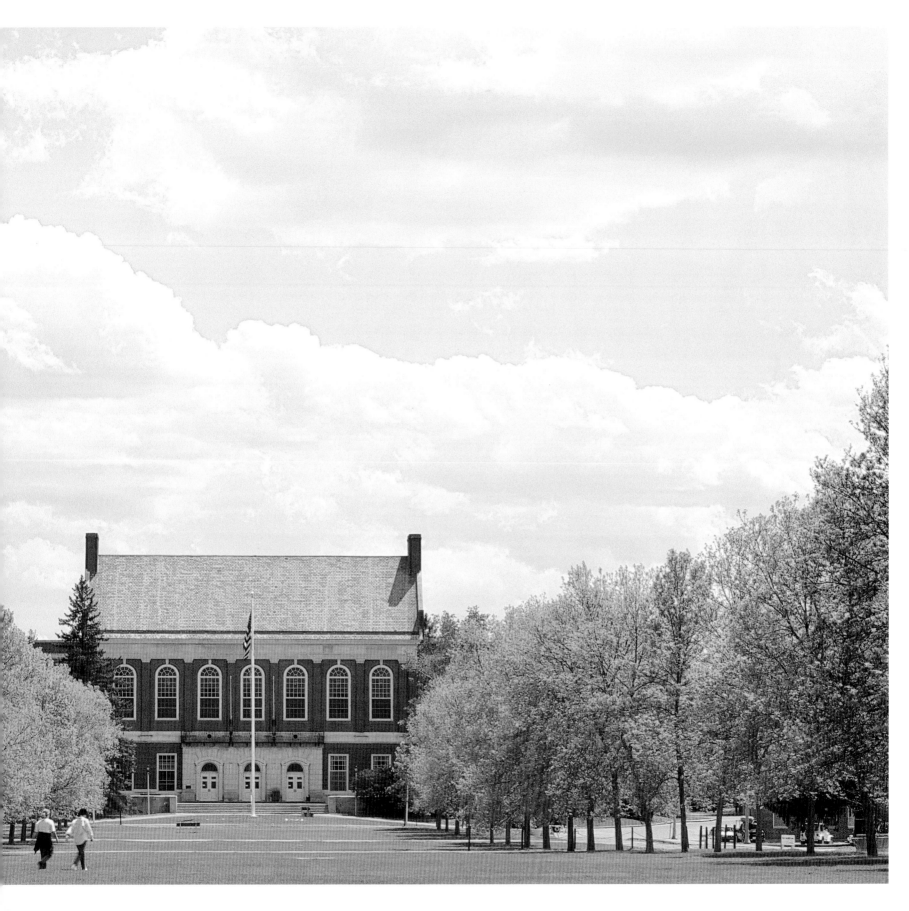

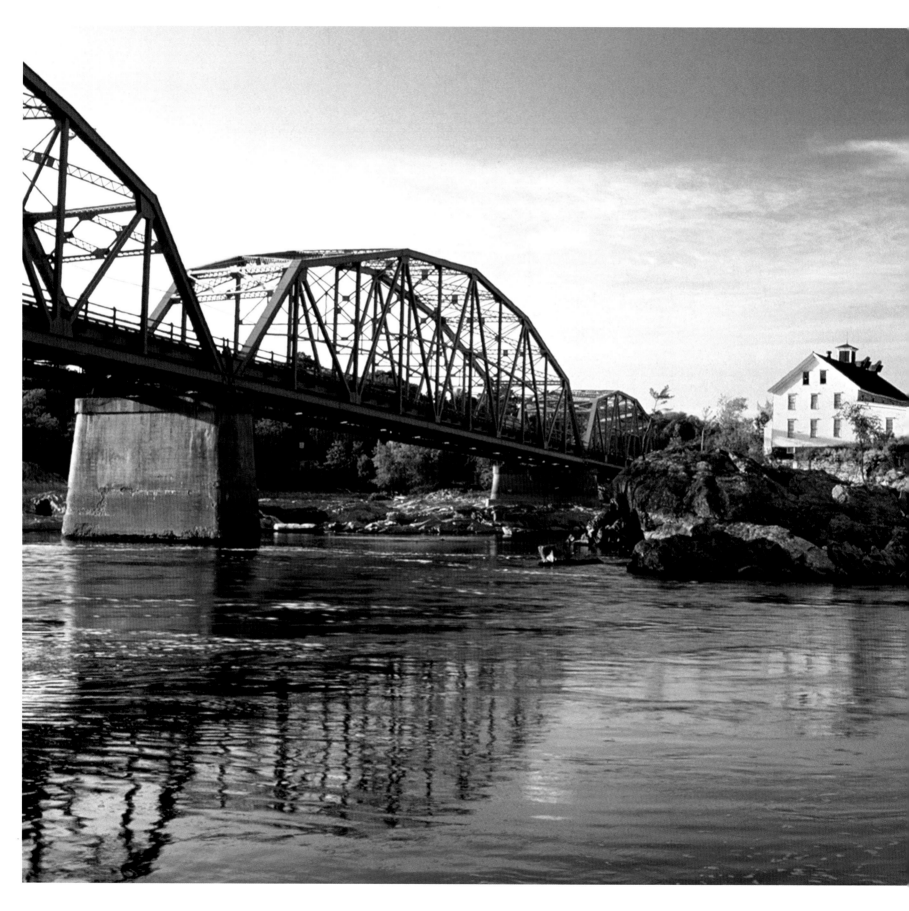

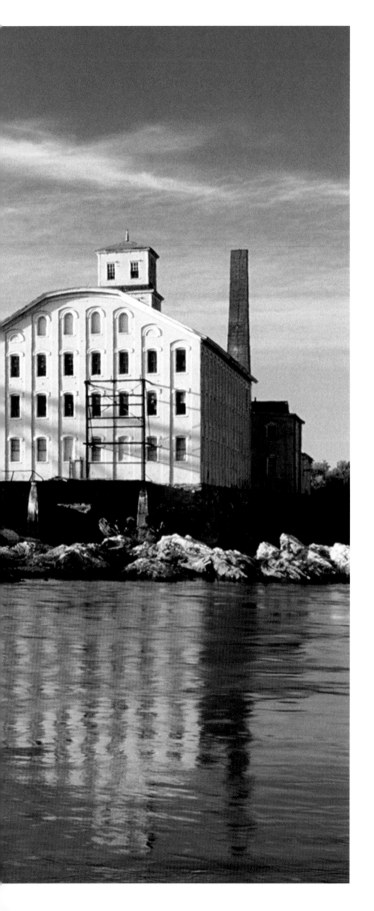

Do you know what this structure is known for?

Since its construction in 1868, this midcoast mill has been many things to many people. Ask passersby and they'll likely mention that the island manufactory once churned out massive quantities of paper. In its heyday around the turn of the twentieth century, the company housed here exported newsprint, book, and school papers as far away as Chile and Australia, and legend has it that the mill holds a world record for paper output. At the height of its production, it could provide a small daily newspaper with six years' worth of paper in a single day. The mill's more recent history has been just as memorable. Many will recall that the compound was awash with floodwaters in 1936 and 1987; one of the state's most industrious rivers runs around the mill's rocky spit on three sides — four in spring — and the river has been known to bloat with runoff from melting snow and heavy rains. The green bridge out front has given commuters passing through this bedroom community of nine thousand plenty of time to familiarize themselves with the mill. Traffic across the span is often dense, bottlenecked by congestion on the busy main street across the river; and all the new businesses located in this area let out. It wasn't always so. When the buildings were first erected, Main Street went purposefully between them, and its pace was far more sedate — except during one of the state's largest agricultural fairs. But that only came once a year. Turn to page 100 to find out more about this industrious spot.

Have you driven the lonely highway that traverses this ridge?

Here we have the king of the hills — or the view from the king of the hills. A string of small peaks lift motorists to beautiful views along a legendary byway in eastern Maine, but this is arguably the most picturesque prospect of them all. What we're after is the name of the prominent natural feature that created the humpbacked rise upon which our intrepid photographer was standing this glorious fall afternoon. It's an alluvial ridge, or esker, created by a retreating glacier that neglected to pick up after itself. As it melted, the ice mountain dropped dirt and silt and gravel, creating a pronounced spine, upwards of seventy-five-feet tall and 2 $\frac{1}{2}$ miles long. When engineers were building the long and lonely highway through the region, a two-lane, ninety-eight-mile road known for its lack of curves, its wild character, and its unusual name, they logically decided to build atop this ridge. Tales persist about nineteenth-century highwaymen who would rob stagecoach drivers here because the pitch was so steep the coaches couldn't outrun them. Today's travelers can safely delight in a lovely panorama of the Union River and the bog that surrounds it. Looking in another direction, you'd see Lead Mountain, a 1,400-foot eminence that you probably wouldn't want to let your kids eat. The town in which this ridge is located is sparsely populated, much like the rest of the communities along this route, save for the two anchors on either end of its run, one of which is among the state's largest cities. The landscape here has changed very little since the glacier passed by, according to geologist David Kendall in his book *Glaciers and Granite*. DeLorme calls the crest "a unique natural area" in its *Maine Atlas and Gazetteer*, which is cartographic code for "really beautiful place worth driving to see." Turn to page 100 to find out how to get to this stunning spot.

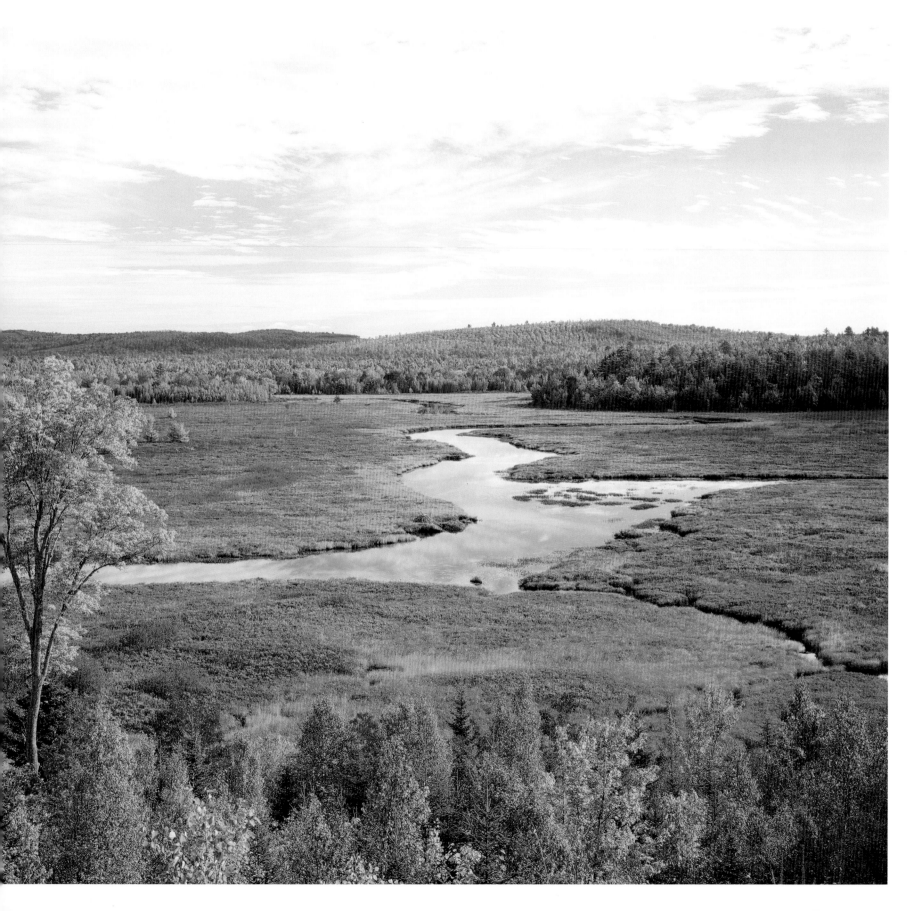

Can you identify this light and its island home?

It may look stunningly scenic at this island outpost on a sunny winter's day, but there are many challenges to face when you live thirteen miles out in the cold North Atlantic. Like cutting your way into your house with an ax. That's how thick the ice gets at this twenty-foot tower, according to one of the more recent residents of the keeper's house. In this community of 1,235 midcoast Mainers, the town manager is also the lightkeeper and thus resident of this 1857 home. Ice was just one problem the former town official faced when she assumed her post a few years back. What took more getting used to was the foghorn. "I thought I was being attacked by God knows what," she told the *Portland Press Herald*. The light here was built shortly before the Civil War under the order of President Andrew Jackson to protect the western end of the island's famous channel. The salty thoroughfare was essential for passenger vessels, for fishermen, and for the merchant ships taking granite out to the world. The stone went into the construction of all sorts of United States landmarks, from the Brooklyn Bridge to the Washington Monument. In fact, if you live on the East Coast, you've almost certainly walked on granite that came from this eight-mile isle, kept safe by generations of lightkeepers. Turn to page 100 if you think you can identify this light and its landmass.

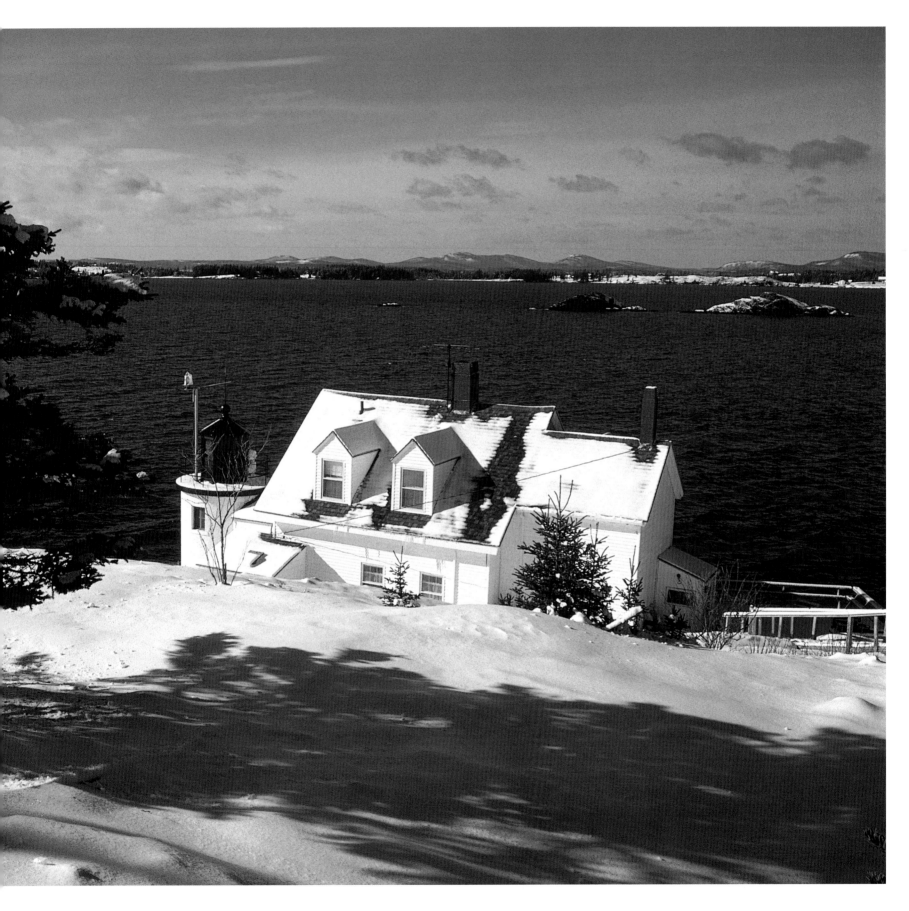

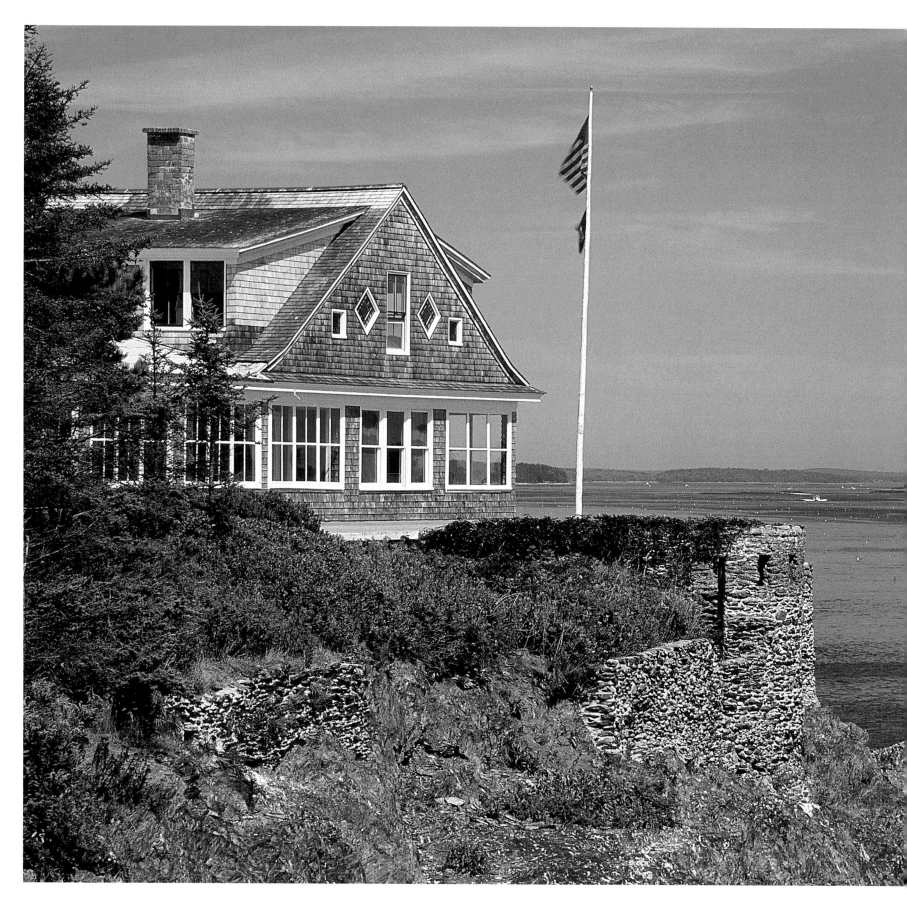

Do you recognize this island retreat?

Not every Maine summer home has its own protective, nonprofit organization to look after it. That's your first hint that this was the house of a notable Mainer. The man who purchased this midcoast island in 1881 was one of the most famous people to graduate from Bowdoin College, a school his name will always be associated with. Though his travels took him away from it more than he liked, our hero always relished returning to this seventeen-acre island in the Brunswick area. He first saw the green isle when he was a schoolboy on a tour of Casco Bay, and ever after he had a restless determination to own it. When he was able to do so, he paid $500 for his own little piece of paradise, and he soon began to remake it to fit his vision. The result of his efforts is dazzling, in a classic old Maine cottage sort of way. Home and Garden Television thought enough of the place to showcase it in a special episode. It's the kind of summer home any Mainer would want, with five gabled bedrooms upstairs, glassed-in porches to take in the vistas, a three-sided fireplace, porthole windows, and a study where our man could sit with a 270-degree view of the sea. The Bowdoin alumn spent many a happy day here after making his name — in a controversial struggle against epic odds — and forcing his way into the annals of world history. Upon the death of his wife, the family donated their beloved summer place to the state, and it's now a historic site and open to the public for tours. The interior is a time capsule, preserved as the military hero might have left it, and pleasant trails await explorers on the island itself. Local tour boats run trips through Labor Day. Turn to page 100 to learn its location.

Ever been to this Maine castle?

Quakers and guns, this place has seen it all. With its wide lawn, towers, and fortresslike façade, this central Maine institution has a medieval air about it. It looks as though it could withstand a catapult siege. That's the first of many ironies about the building, which sits in a village between two of Maine's largest cities. Though it appears rugged and defensible, the peculiar-looking edifice's history is rooted in nonviolence. A group of Quakers migrated to this quiet farming community from New York state shortly after the American Revolution, and built a seminary on these grounds in 1848. They built their new school on 330 acres, amid a grove of oaks and overlooking one of the state's largest rivers, and to this day have an active church in town. Those buildings are long since gone, and in the twenties or thirties, the Tudor-style castle shown here was put up in their place. For the better part of 150 years it was an educational center. It served as a girls academy for a long time, and later became a co-ed, college-prep boarding school. The campus was occupied until 1989, when the school went under and the facility was subsequently purchased by the state and then left vacant for a decade. In 2000, after extensive renovations, it reopened as an academy of a different sort. The property's Quaker history has proved a bit problematic for this new educational institution, though, because the new school wanted to use guns on the grounds and the Quaker family who donated nearby land to the previous tenant did so under a provision that specifically forbade firearms. The situation has been tricky, but it looks to be sorted out. Check page 100 to see its location.

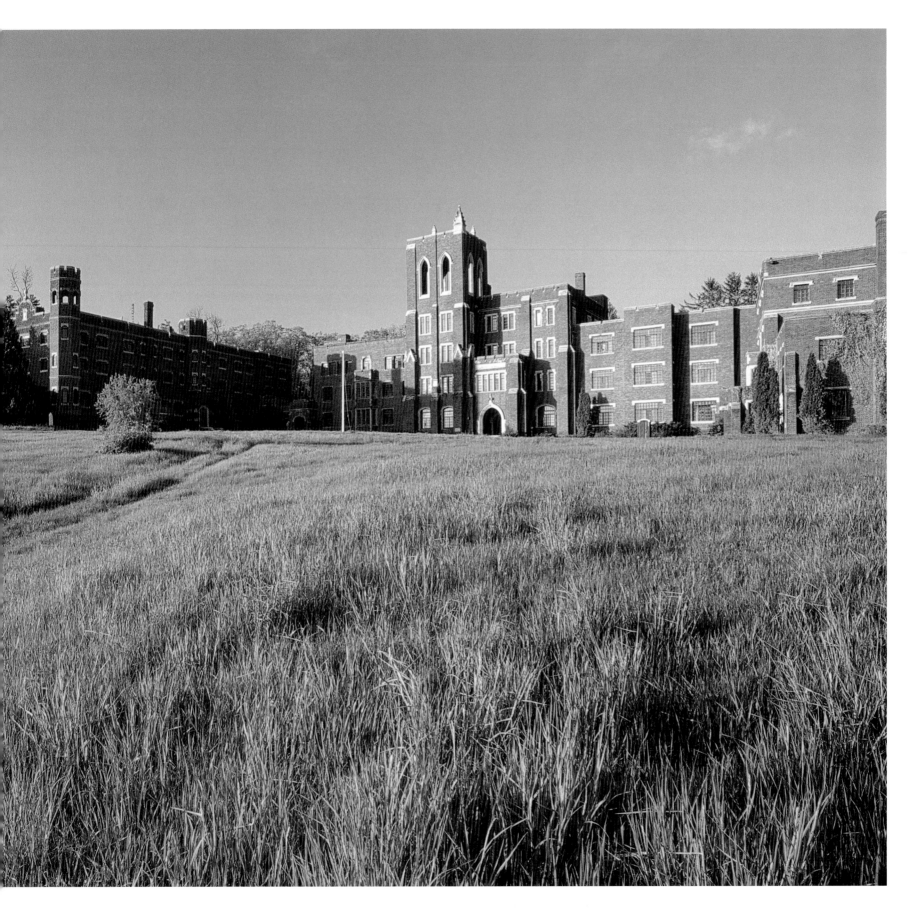

Can you identify this inspirational isle?

With a single glance you can understand the romantic appeal of this place: a lovely Victorian house on a tiny windswept isle, lorded over by highlands, surrounded by the Atlantic. This beauty is what attracted a virtual parade of writers to this island on the Down East coast. If ever there has been a lighthouse that was home to more authors, poets, and playwrights than the one pictured — suffice to say, we can't find it. The first scribe to land here was likely Bernice Richmond, who bought the island after the Coast Guard deactivated this light, used to protect a chilly harbor, in the 1930s. Next up in the 1950s was children's book author René Prud'hommeaux, author of *Hidden Lights*, *The Port of Missing Men*, and *The Sunken Forest*. She was followed by playwright Gerald Kean. And most recently it was owned by William C. Holden III, a retired banker who wrote several novels while living here. In *Our Island Lighthouse*, Bernice Richmond describes the allure: "It is hard for people living on the mainland to understand the contentment found on an island . . . I couldn't put into words . . . how terribly important it was to sleep on the island with sea sounds encircling me. I couldn't explain how I looked forward each morning to that first rush of salty air through my kitchen door. . . ." If you can identify this inspirational isle turn to page 100.

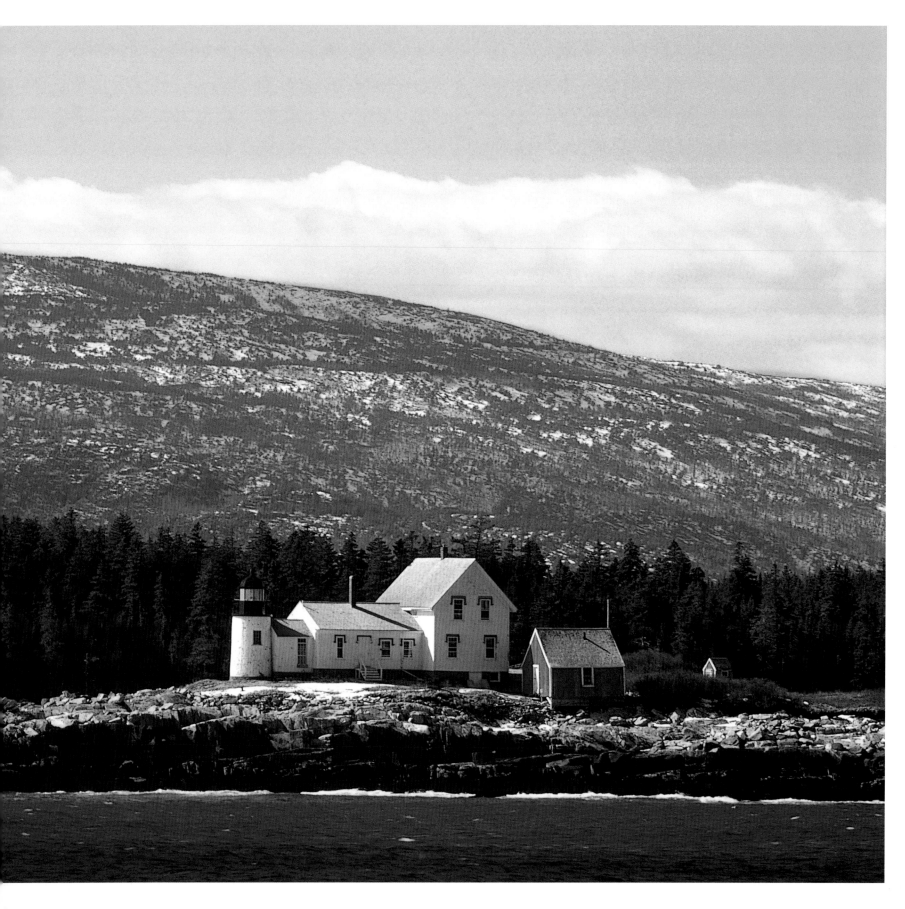

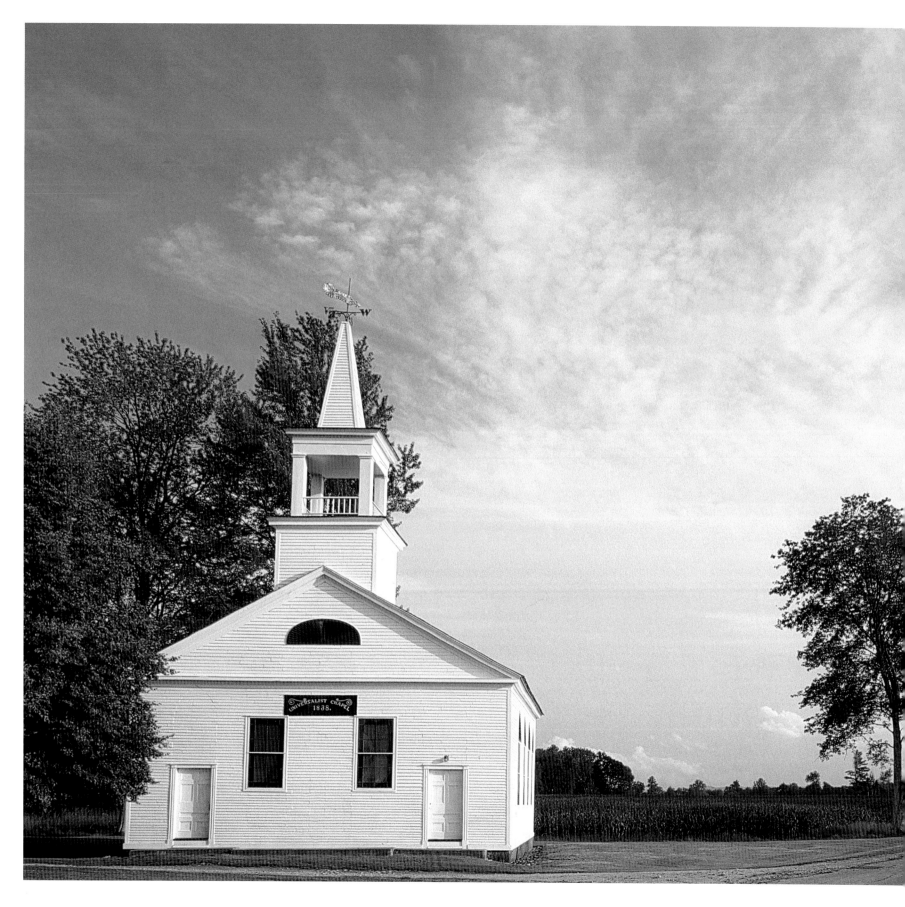

Are you familiar with this western Maine community?

Perhaps we should really be asking "Where in New Hampshire?" Motorists driving through this western corner of Maine are often unsure which state they're in. This church is indeed in the Pine Tree State — but just barely. It sits about a mile from the border in a very quiet section of town on a road that slides in and out of the Granite State on its way north. The real question, though, is where is the rest of the village and, why is this sweet, white Unitarian church by itself on a corner with nothing else around but a cornfield? Meetinghouses, as all who have been to New England know, are usually at the very heart of a community. Someone who might have known why this church was built here was Admiral Robert Peary, famed explorer of the Arctic. He was once a surveyor in town. Orator and politician Daniel Webster could have had an explanation, too, or at least would have convinced you that he did — he once wrote deeds here to supplement the income he made as a teacher at the local academy. Hopa-long Cassidy, legendary Western hero, is another proud son of the town, created by resident Clarence Mulford in the early part of the twentieth century. And art great Eastman Johnson once painted landscapes here. But on this pretty late summer day no one seems to be around to ask. It just might be that everyone has gone for a paddle down the state's most popular canoeing river, which is nearby. Or they could all be at home getting their prize produce together for the local fair — the state's largest county fair turns this picturesque riverside town into a big carnival at the beginning of October each year. See page 100.

Can you tell where this museum is located?

If this romantic scene has you imagining an earlier time, picturing bonnets and buckboards, you're on the right track. Every October the centuries melt away at this small village in the central part of the state and people cross this covered bridge into the 1790s. Men and women in period dress demonstrate what it would have been like to live a pioneer life in the North Woods, working at a water-powered sawmill or a blacksmith shop, spinning or weaving, traveling by buggy and bateaux, and feasting on bean-hole beans. Even the children are busy, dipping candles, making cedar shakes, and peeling potatoes. With the bridge, the mill, log cabins, trapper camps, and nature trails through the woodlands all around, it's not a bad way to spend the first weekend in October. The museum here is no stranger to living history, dedicated as it is to telling the story of the long-ago lumbering life of the Maine woods. Every autumn it hosts this colorful event, transforming this community of 1,242 into Township Four, the place it used to be. Have you ever stepped across this bridge and back in time? Turn to page 100 if you can identify the museum or the community it is located in.

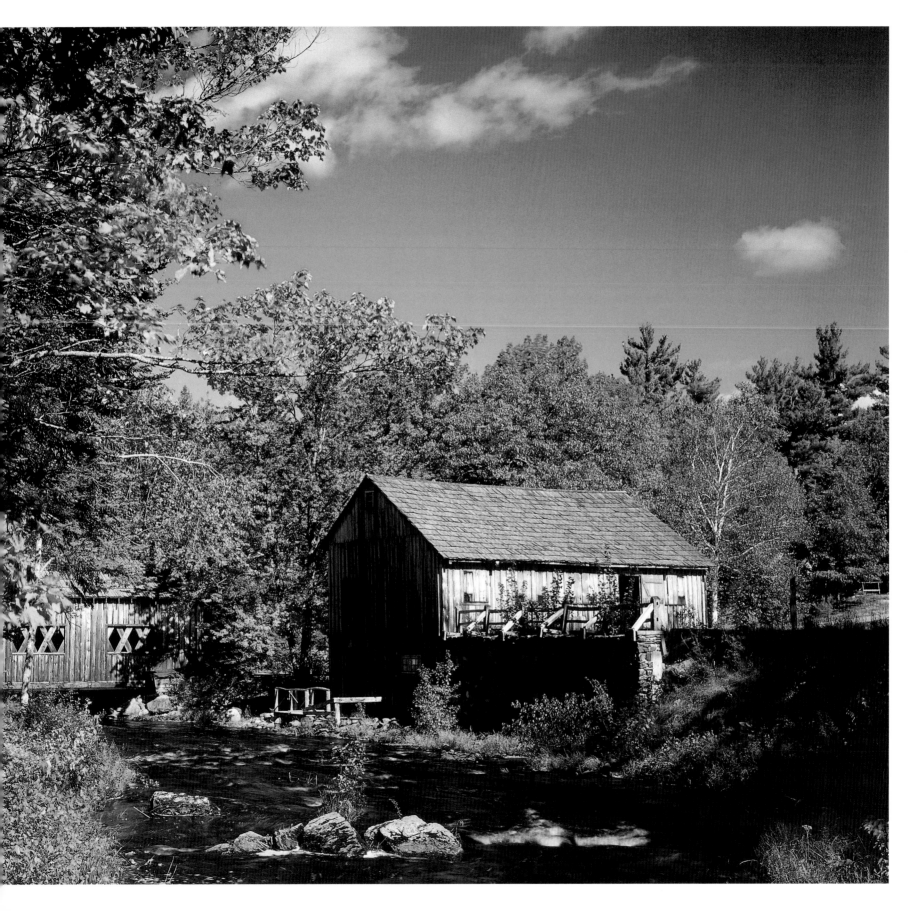

Have you flown over this island community?

A brilliant, sunny day in midwinter is cause for celebration in this small Penobscot Bay village. Much of the town is open and exposed to the unforgiving Atlantic, and in the cold and dark months the world beyond the bay seems very far away. Ice and snow hamper transportation, and with plummeting temperatures, lobstering, the principal occupation of the community, becomes even more arduous. Yet, somehow fishermen here still manage to bring home a lobster harvest that is among the largest in New England. But when the weather is disagreeable, simply getting to Rockland, fifteen miles away, to do some shopping, can be an ordeal. The harshness of winter fosters a sturdy neighborliness in town, a unity that some of the five thousand summer visitors who quadruple the year-round population each summer might even call insular. Residents of this particular spot — known locally as "the rock" — have a reputation as a hardy lot, as tough as the granite their forebears extracted from turn-of-the-twentieth-century quarries, especially in contrast to their nearest neighbors, a haven of affluent summercators to the north. The town was named for the man most responsible for its incorporation in 1789, but in recent years it's been artists such as Robert Indiana who have put the place on the map. Indiana is one of a small colony of artists who have come to town to paint the pointed firs and the hyperactive surf. Though this view isn't the typical postcard panorama — it's unusually expansive and maybe even a bit misleading — it does provide a slew of clues. Can you spot them? The answer is on page 100.

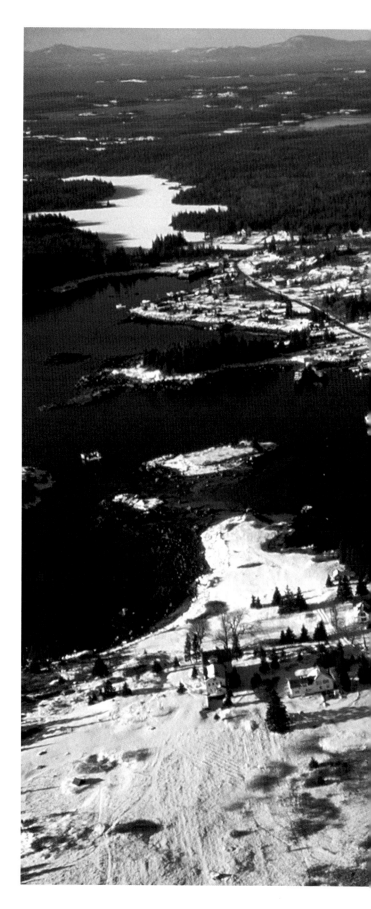

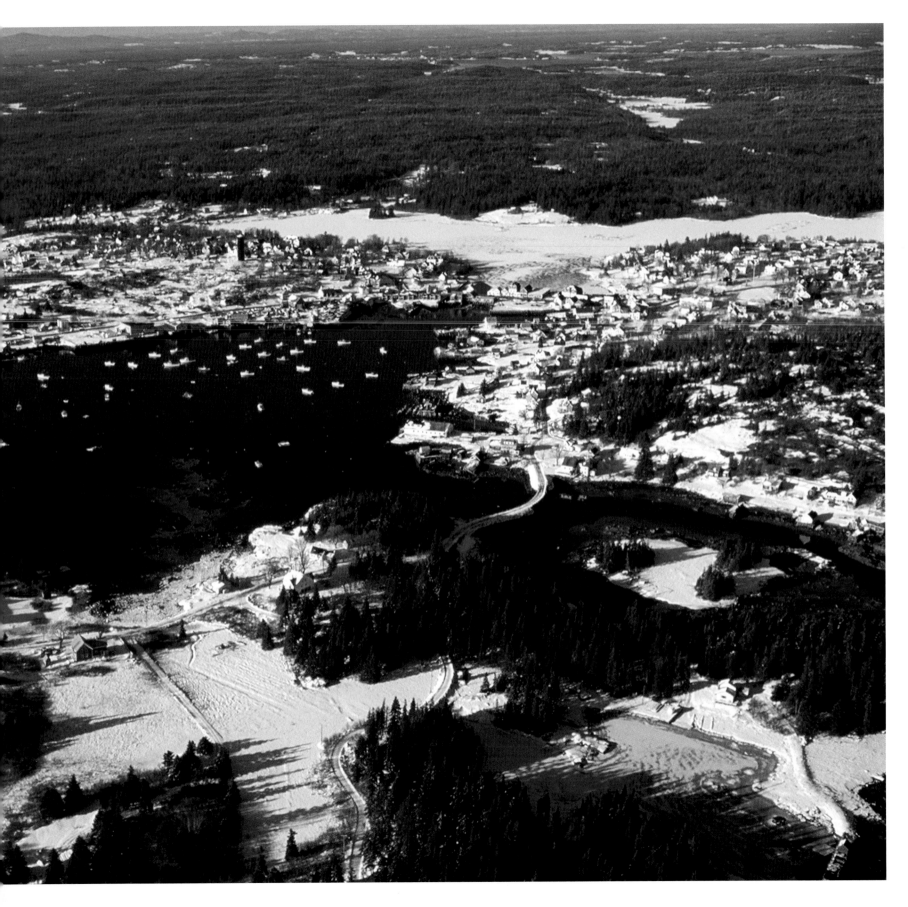

Can you identify this Arnold Trail campground?

If Benedict Arnold and his army had campsites like these when they passed through the howling wilderness here in 1775, perhaps their expedition to Quebec would have had a happier ending. Today's campers are happy indeed at the shore of this lake in the western mountains. The three hundred-acre campground is a popular place come summertime, with 115 sites overlooking one of the state's larger freshwater basins. Known for its stately red pines, this community-owned facility has a boat launch, playground, and recreation hall. The activities nearby are many, from hiking those peaks in the distance (among the state's tallest), to boating, to watching moose at the local "drive in." The town that surrounds this peaceful spot is tiny — 685 souls — but you can find almost everything you need for a summer spell right here. Turn to page 100 if you can identify this Arnold Trail campground or its scenic setting.

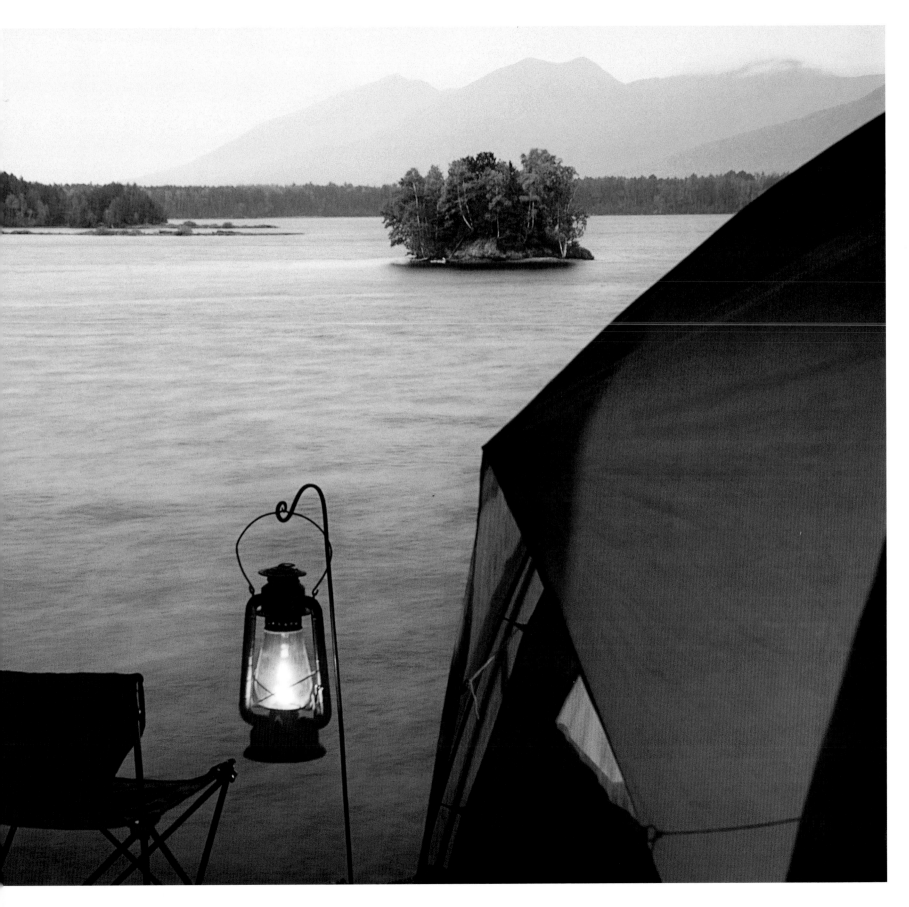

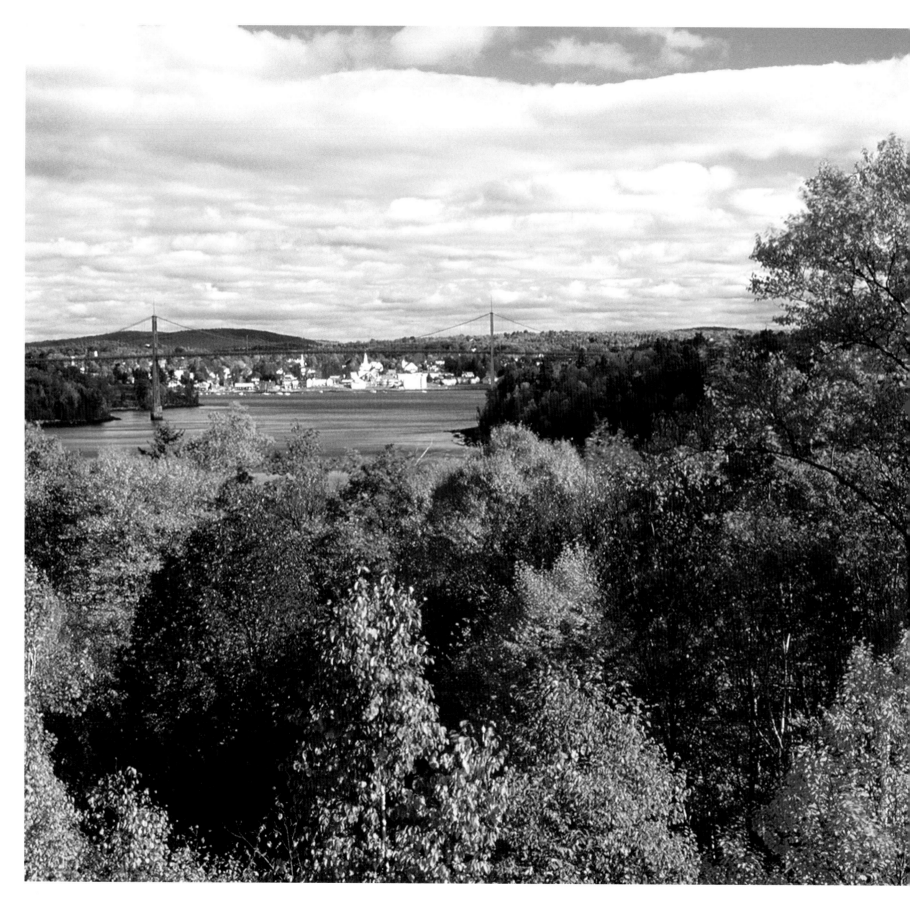

Have you ever driven over this bridge?

Surrounded by a panorama of leaves that seem almost enthusiastic in their glow, and suspended far above one of the state's most powerful rivers, this bridge neatly frames the antique steeples and spires of a white-clapboarded Yankee village, seemingly embraced by the forest. It's a scene not easily forgotten — but it looks a little different today. Although the lofty span may seem infinite to gephyrophobes, it's only the state's sixth longest, on a well-traveled interstate route not far from the city that calls itself the gateway to the North Woods, and a stone's throw from one of Maine's most historic sites. Perhaps you stopped in this small, photogenic community of five thousand for a night or two at the town's venerable inn? If so, you were in good company, historically speaking. The hostelry is one of the nation's oldest, with a guest register that has been signed by a host of key figures in the history of the United States — Presidents Jackson, Tyler, Van Buren, and Harrison, as well as Jefferson Davis and Daniel Webster — most of whom came to the area to settle a border dispute with the British. Things were tense again a few years ago, when a small grassroots group stared down and ran out of town a corporation bent on building an enormous coal-fired power plant. There is already a pair of imposing smokestacks on the skyline here; the townspeople made it clear they didn't want any others. The paper mill at the base of one of those stacks — and the river that flows beside it — provide the economic backbone for the community and many of its neighbors. Look for this view today, of course, and you'll have a tough time. An equally impressive connector runs through here now — but this stately span remains. See page 101.

Do you know the names of these dangerous rocks?

It all began with a licentious affair between a king and his lover, a married woman. At least that's the apocryphal explanation for the name of this pair of rocky ledges off Maine's midcoast. Apparently they were named after some similarly intimate rocks in the Thames, which were given to a man whose wife King John had gotten to know (rather too well). Very naughty stuff. In Maine this siren and her mate have been angry lovers since boats starting plying the waters around them, lashing out at many vessels and sinking their share. They mark the entrance to a busy fishing harbor, and until the late nineteenth century, all that warned mariners away from their dissolute and deathly grasp was a simple tripod beacon placed atop them. In 1892, a stone fog signal was built here, but the ship-wrecks continued to claim boats and lives. So a light tower was built in 1907, one of the last lighthouses to go up on the coast of Maine. With a normal tide, the sea claims all but fifteen feet of rock here, and when it storms, there's little to protect the light from taking a fearsome thrashing. In January of 1933, the lightkeeper's home was flooded, and the assistant keeper was reimbursed by the Department of Commerce for the loss of his radio and Hawaiian guitar. Close to fifty years later the keeper's house was totally destroyed. Not even the guitars made it that time. The octagonal tower was automated in 1975, and made its way on to the National Register of Historic Places in December 2002. Today, you can read a memoir by the former keeper, buy a not very sexy ceramic replica of the light for $95 (www.collectiblesrome.com), and get a boat ride out to see these adulterous rocks from a number of local cruising companies. Turn to page 101 to see where they're located.

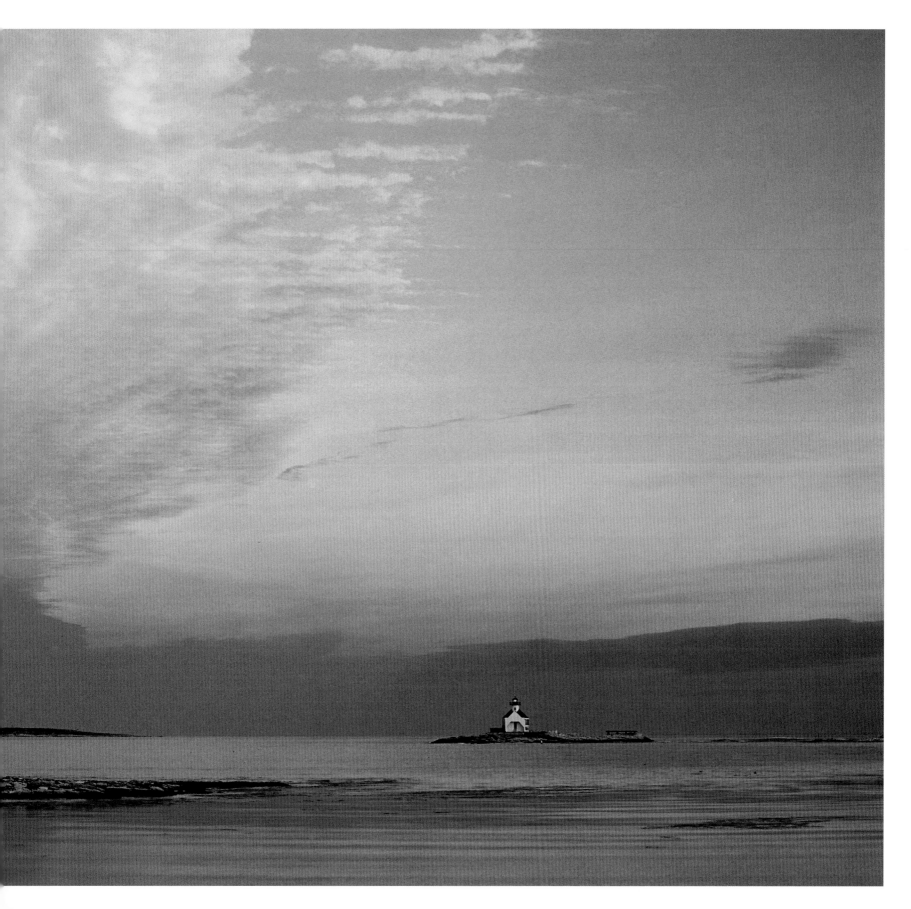

Have you enjoyed spending time at this preserve?

Under the October sun, this stretch of shorefront looks like Anyplace, Maine. The rocks push out into water that might be a river, might be a bay. The trees glow pleasantly against the blue, the air is clear, and the light is bright. This photo could have been taken anywhere. But these 500 acres are actually quite unique, making for a piece of rarefied real estate with so many fine features that not one, not two, but four different state and local agencies banded together in 1989 to preserve it in perpetuity. This is, in fact, a headland on one of the midcoast's more important (and multisyllabic) rivers, and it attracted the attention of preservationists for a number of reasons. There is more than eight thousand feet of river frontage here, with pocket sand and pebble beaches; there are old-growth trees along with several notable plant communities; there are native shell middens; and the remains of a brickyard that turned out building blocks in the late nineteenth century. These days the local economy runs on oyster farming, commuting (to the larger Route 1 towns), retirement communities, health care, and tourism. The Bureau of Parks and Lands manages this park for "hiking, clamming, worming, skiing, swimming, nature study, habitat management, and forestry demonstration." Which is a long-winded way of saying that people like to recreate here. On days like the one pictured here, it's foliage that provides the draw, and there is plenty of it in this former State of Maine Tree Farm of the Year (1978). See page 101 to learn its location.

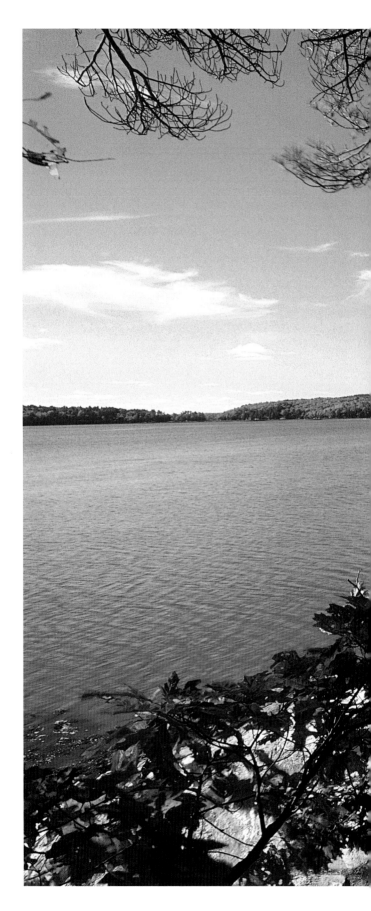

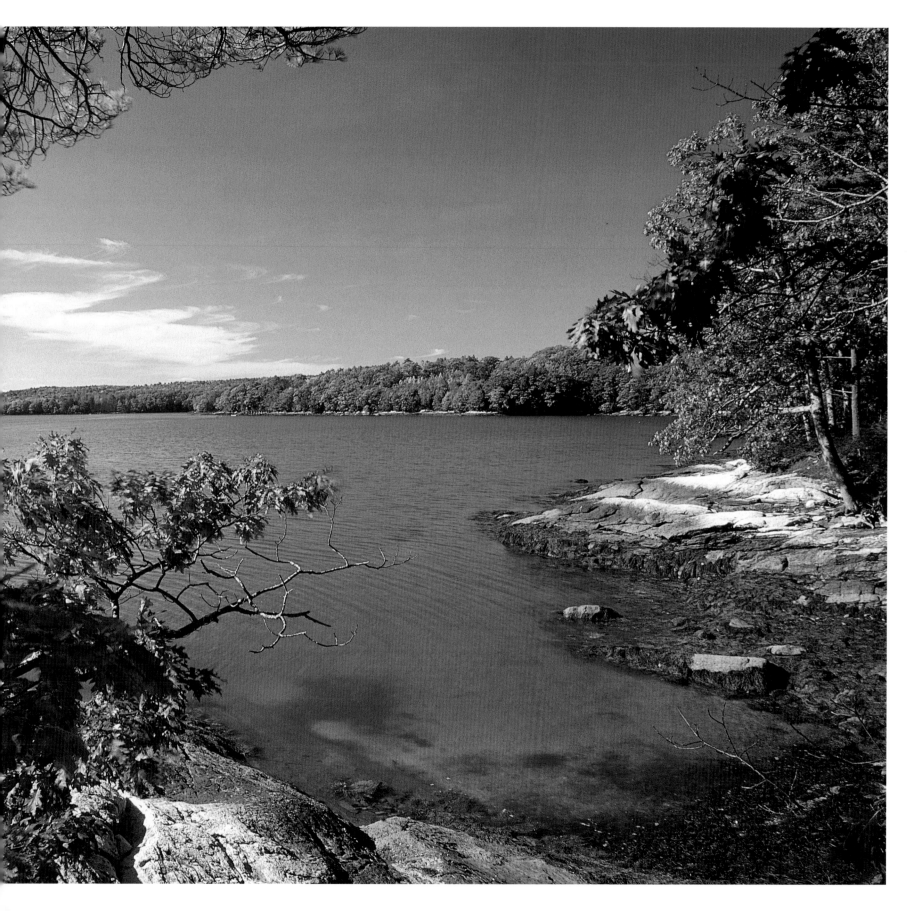

Can you identify this terrific tannenbaum?

The festive fisherman who came up with the lobster buoy ornament was pretty clever. Evergreens can be found up and down the coast festooned with colorful floats, and they always seem fun and festive and fitting. But a Christmas tree actually made out of lobster traps is another thing altogether. That's the kind of old-timer ingenuity — or the work of a crafty chamber of commerce — you don't get in every port. (Cape Porpoise, incidentally, claims the first trap tree). But there's probably no more deserving place for such a spectacle than this rock-ribbed city of 7,609. This harborside burg has become rightly famous for its fishing industry. It also knows how to party. Popular festivals bring some of the state's largest crowds here in the summer. Come the holidays, Lermond Cove celebrates with a parade of lights, Santa arriving on a Coast Guard vessel, horses and carriages tugging people through the historic streets, and this "tree" getting lit. Have you ever seen the Lobster Trap Tree? Turn to page 101 to see if you're correct.

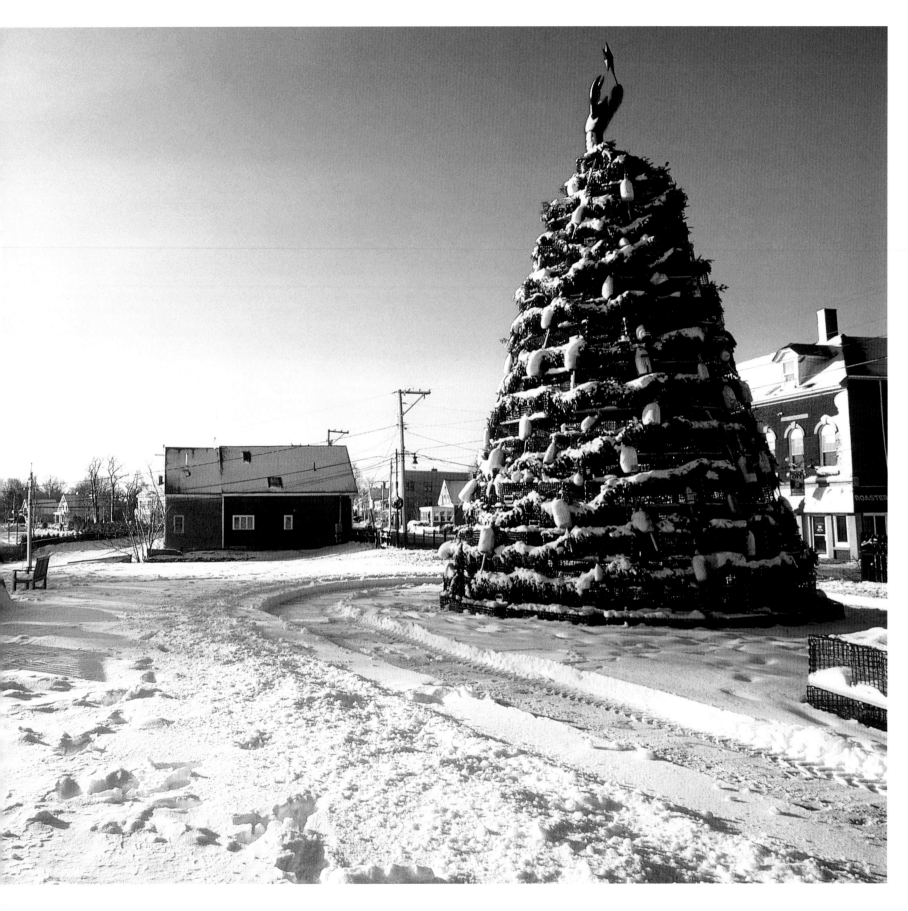

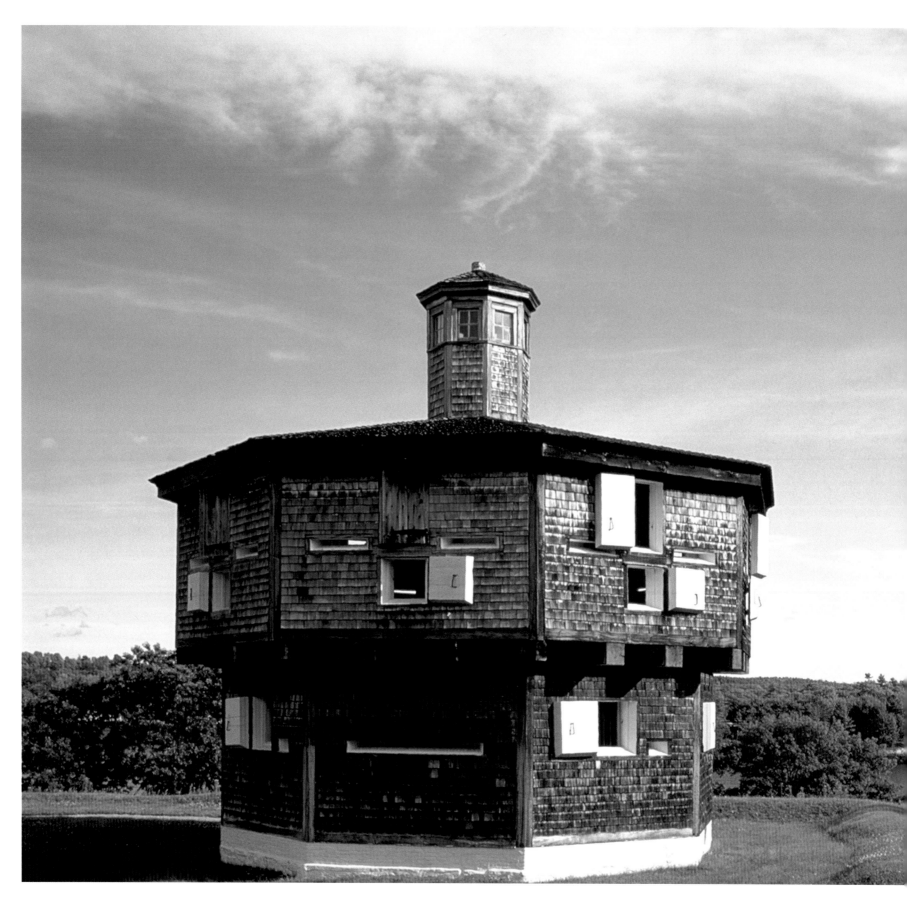

Have you ever found this forgotten fort?

If you're like many Maine motorists, you've driven within a mile of this old blockhouse dozens of times and never known it was there. Built in 1809 to protect a busy midcoast shipbuilding harbor, the fort sits just off Route 1 on an island few Mainers realize is an island, overlooking one of the area's largest rivers. The solid little citadel was the focal point of an impressive compound at one time, with heavy bunkers, palisades, and a waterfront battery, and it was garrisoned for much of the nineteenth century, as a 1985 archaeological excavation revealed. And the site saw a few tense moments — it was threatened with bombardment during the War of 1812, and fifty years later the Confederate cruiser *Tallahassee* passed menacingly by not far downriver. Today the fort still sees quite a bit of action, but its many invaders are armed with nothing more threatening than cameras, Frisbees, and overflowing picnic baskets. (The solitary ranger who now mans the octagonal fort would be instantly overwhelmed if the park's many day-trippers mounted an uprising.) Home to an interesting historical display, the blockhouse is one of the nation's best preserved forts from the period and became one of Maine's earliest state-owned parks, purchased in 1923 from the U.S. War Department for $501. Wide, grassy swaths overlooking the river and views of seals and ospreys have since made the spot popular among locals and those taking the scenic back way to a famous resort harbor not far down the road. Things are totally serene on the scene these days — especially under a fair May sky — but there are a few visitors who wish they could blast an unsightly old power plant out of the view across the river. See page 101 to learn where to find it.

Can you guess the location of this curious cascade?

No, it's not Wyman Dam. This little river embankment is not likely to be confused with that monumental waterstop on the Kennebec, but on a fine autumn day, it definitely has a grandeur all its own. If you were a kid in the '50s, you might have known the pool above this dam as a local swimming hole in a small midcoast city. If you were a duck hunter in the '60s, you might have known it as a great place for wingshooting. If you live hereabouts these days, on any one of a dozen streets graced with stunning Greek Revival and Victorian Gothic architecture, you might venture down to walk the neat new trail here. The community was established by a colony of Scotch-Irish who emigrated from Londonderry, New Hampshire, in the 1760s. The burg that arose was to be named for that Granite State town, but settlers opted to call it after a city in Ireland. Within the next century it would become famous for shipbuilding, and a century after that for its poultry-processing industry, until in the 1970s the whole area seemed to chicken out. That was about the same time when the surrounding county was subject to a pleasant invasion by back-to-the-landers captivated by the rural countryside and the fine old architecture. (Many of the beautiful buildings downtown went up in the 1870s when the city was putting itself back together after a catastrophic fire.) The dam and this graceful old structure date back to 1888, erected to serve as a reservoir and a pump house, providing the city with its water. It's maintained for the same purpose today, although it now is a backup to a system of wells that the burg gets its water from. You can't swim here anymore, nor can you hunt. But you most certainly can enjoy the view. Turn to page 101 to find out where to find it.

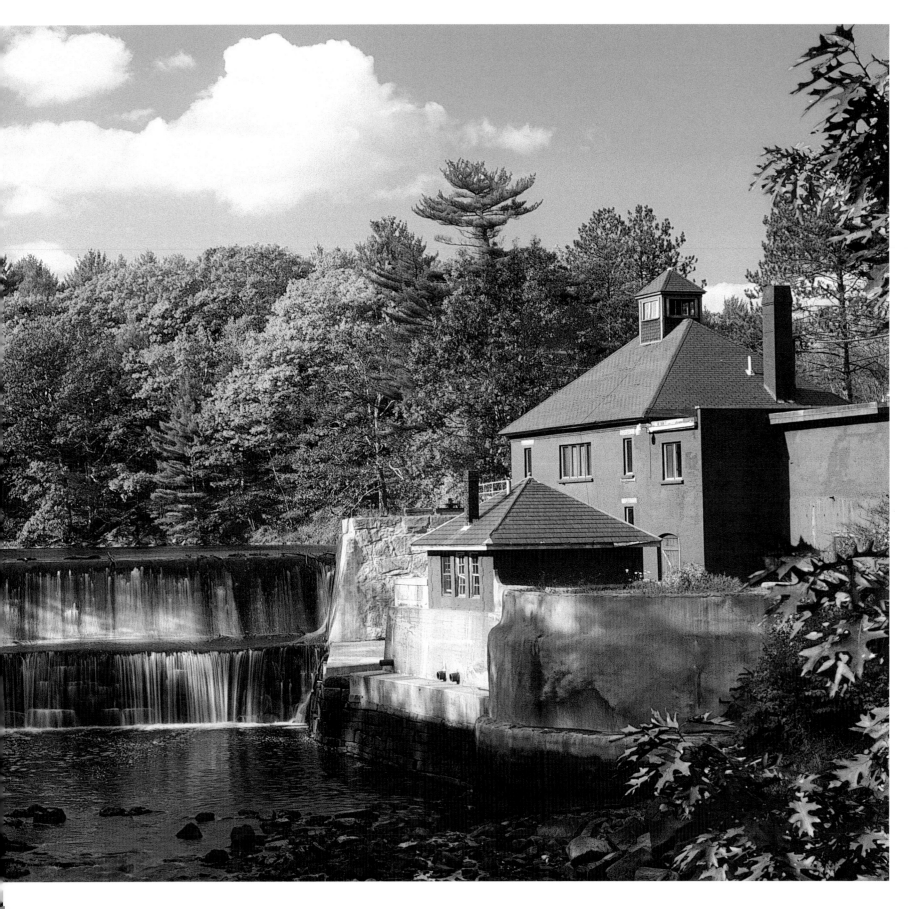

Have you been soaked by Maine's Ol' Faithful?

Granite chasms don't come much more renowned than this foaming sea pocket. And you'll look long and hard to find one that speaks with its own basso profundo. Maine's answer to Ol' Faithful, it sits at the edge of a Down East island, where it gurgles and belches and occasionally blasts water into the sky. Like its counterpart at Yellowstone, it works on its own schedule and requires patience from its audience. When most people visit they find it quiet, the sea gently rocking in and out of the twisted cavern, and they wonder what all the fuss is about. When the surf and turf decide to put on a show, though, it's a sight, one of the Pine Tree State's great natural wonders. The waves leapfrog madly off the rocks, soaring as high as fifty feet in the air. They crash spectacularly with a resounding, earth-rocking thud (Thor would be proud), soaking everything in the vicinity, including anyone who might be standing near these railings. In summer that's all great fun, and hordes line up to bathe in the spray. Come February it's another thing altogether. The great irony is that one of the best times to view this particular attraction is on a blustery winter day, and that's when the viewing platform here is usually empty. If there are flakes aplenty, snowmobilers and cross-country skiers, even the odd snowshoer, might have a look at the spectacle. If not, walkers and hardy hikers might wander down. Other than these and a handful of folks who work in the area, the only witnesses to the tempests of winter here are shorebirds. See page 101 to find out how to track it down.

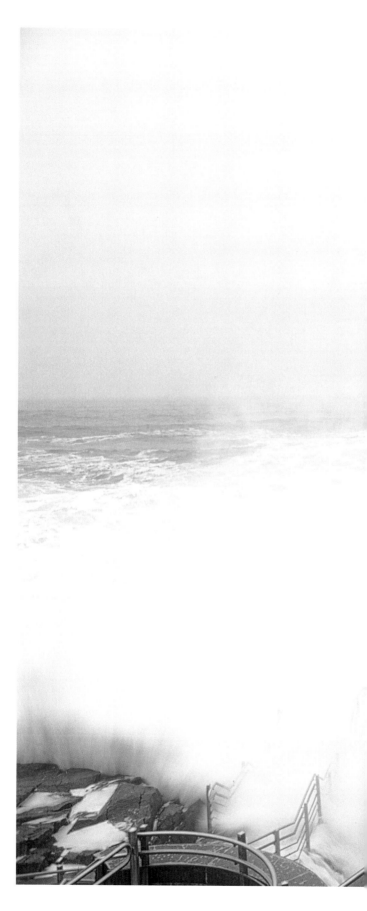

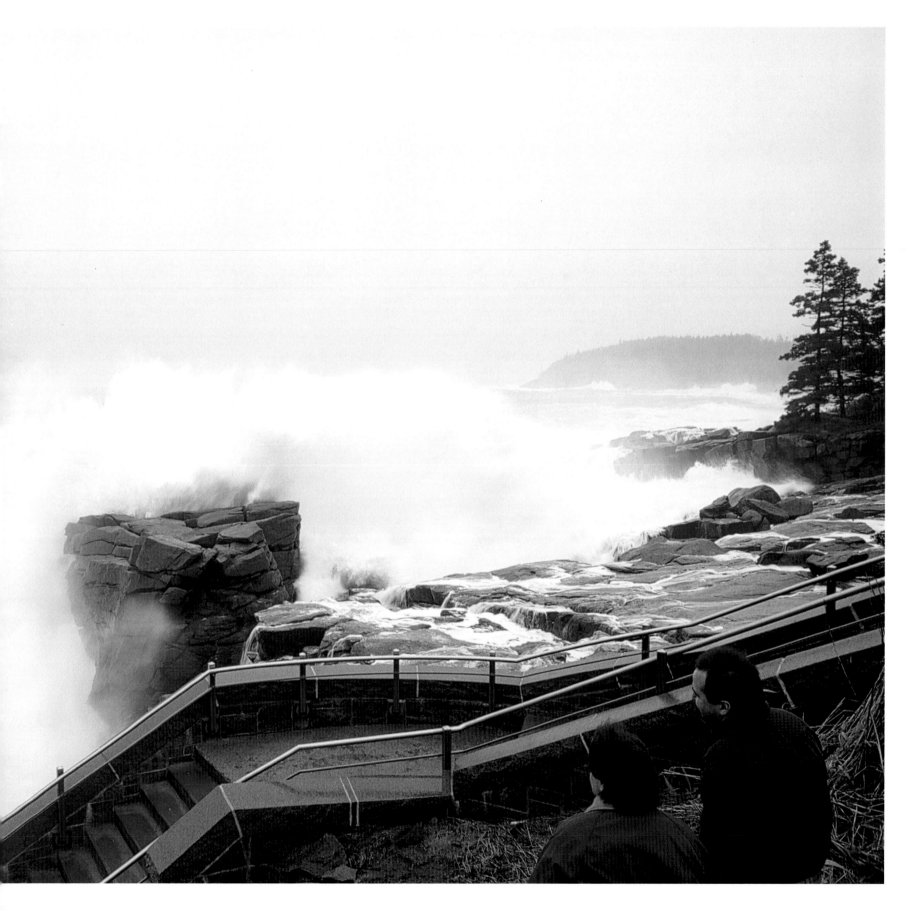

Have you been to this historic garrison?

This diminutive outpost doesn't seem quite sturdy enough to stop rampaging French and Indians, does it? Luckily, this blockhouse was only one small part of a much larger fort, which was built in 1754 to protect the locals from just such an attack. The structure was sufficiently stout to survive for centuries — it was the oldest of its kind in the nation — until the great flood of April 1, 1987. That's when one of Maine's larger rivers broke its bounds and flushed the blockhouse and a lot of other stuff downstream. By that time the fort was part of a popular state park and the focal point of the community, which had literally sprung up around it. So the good people rebuilt it, using as many of the original timbers as they could collect. (Some had floated forty miles.) Have you been to this historic garrison? Turn to page 101 if you think you can identify this riverside spot.

Do you recognize this great lake?

If it weren't for a small change in the wording, we might be calling all the people who live near this great lake the Flintstones. The original name of the community here was Flintstown — it was part of a grant given to a Revolutionary captain whose surname was Flint. Of course, many Maine villages were swallowed up when towns incorporated or joined with other municipalities, and that's just what happened along the shores of this massive waterbody. At forty-seven square miles, this isn't the state's largest lake — that would be Moosehead — but it is the deepest. Even before the Flints moved in (the lake's name is an Abenaki word for "large open water"), everyone has wanted a piece of this basin. In 1877 there were even armed clashes here between corporations interested in the flow of water to their downstream mills, a conflict — the Basin Dam War — that spun into the courts for years. In the following decades, the mills quarreled with the nascent tourism industry. The new hotels needed water levels high enough to move their cargo — affluent summer guests — while the mills were more concerned about letting enough water get downstream. Now the challenges facing the lake are issues like Jet Skis and the invasive effects of milfoil. Makes one long for the simple times of Fred and Barney, Wilma and Betty. See page 101 if you recognize this great lake.

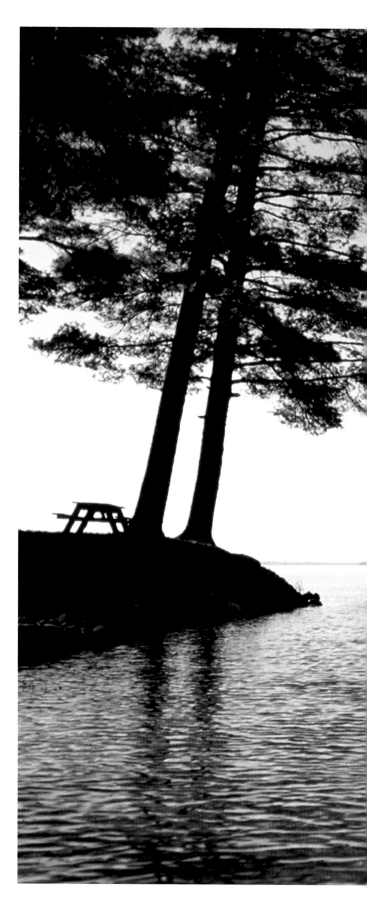

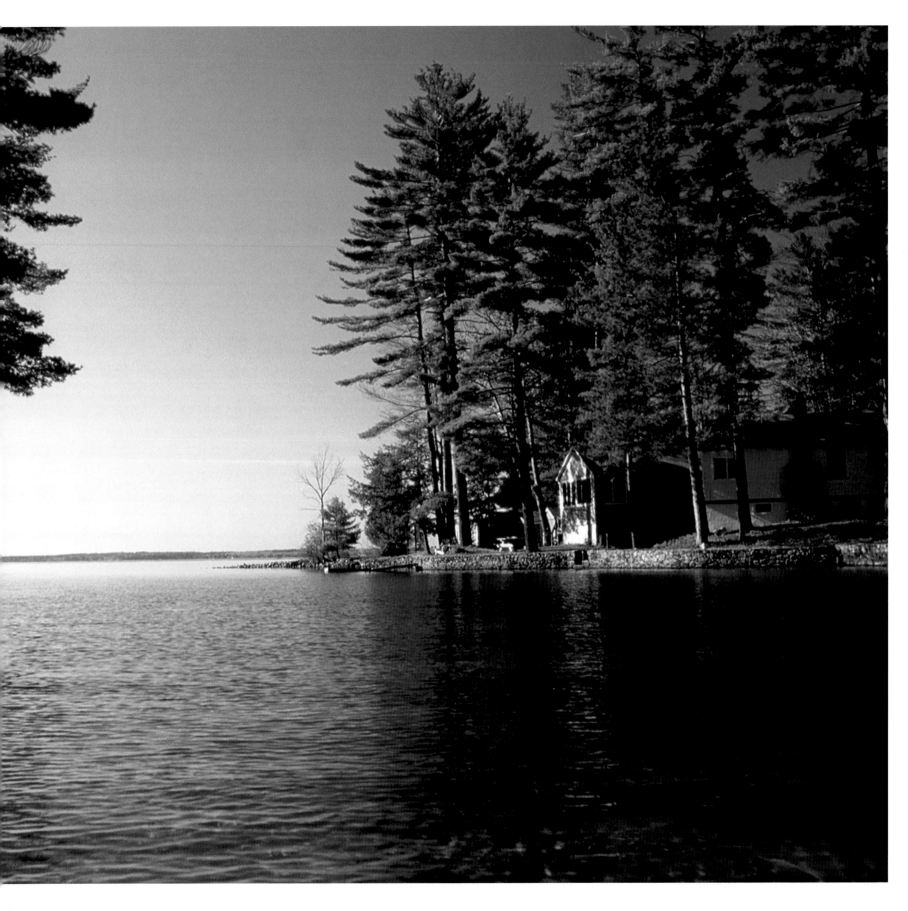

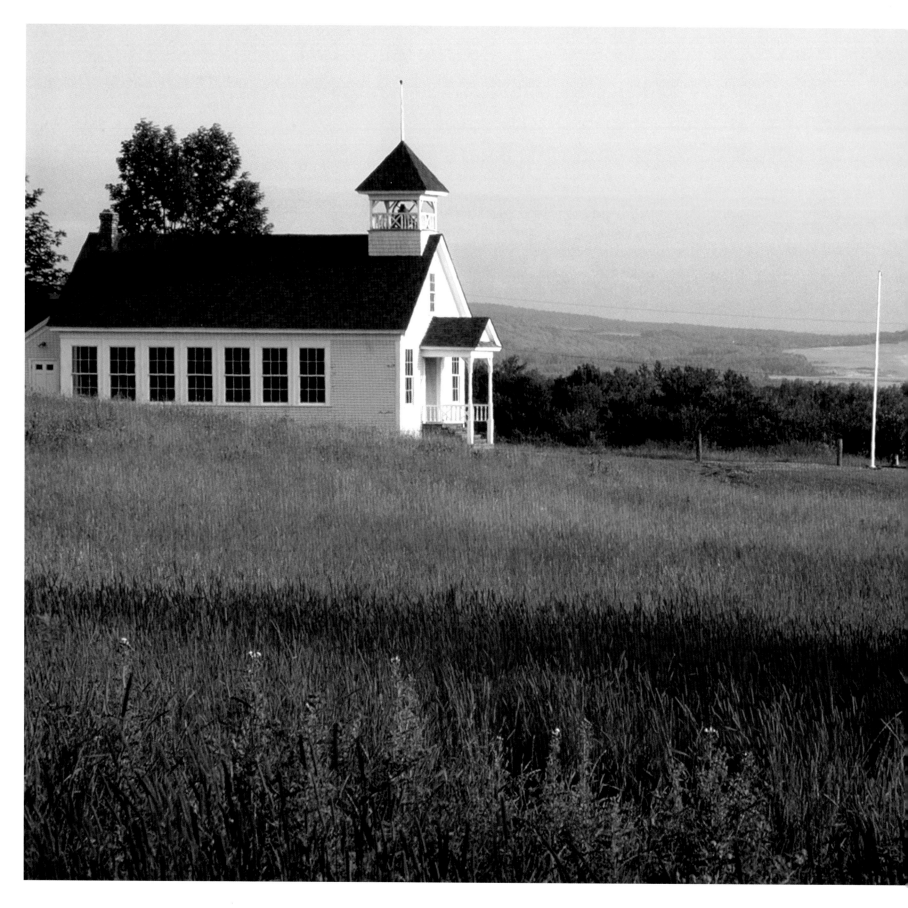

Does this old school ring any bells?

And Maine teachers today think they have it rough. Shortly before this school was built in 1917, educators — primarily women in those days — were given a rather severe set of guidelines by the state to which they were expected to adhere: 1. You will not marry during the term of your contract. 2. You are not to keep company with men. 3. You must be home between the hours of 8 P.M. and 6 A.M. unless attending a school function. 4. You many not loiter downtown in ice cream stores. 5. You may not travel beyond city limits unless you have the permission of the chairman of the board. On and on went the prohibitions.

The city in question here is in northern Maine, and the school pictured sits in a neighborhood called Spragueville. According to local history, kids attended the old schoolhouse through the eighth grade up until after World War II, when area schools were consolidated into School Administrative District No. 1. After that the place was used as a church for a decade, and then left to the winds and snows that tear across the rolling hills for which this part of Maine is famous. In the eighties a group of area residents decided the school was worth restoring and set to it, finishing the job in 1987. In recent years the graceful clapboarded building has been the setting for a program somewhat ironically called "a day in a country school," which brings local "city" kids to Spragueville. The irony is that this entire region is generally thought of as Maine at its most agrarian and rural. Farming put it on the map (along with a certain military installation) and many of its 9,511 citizens still make their living working in the fields. See page 101.

Can you name this southern Maine coastal community?

You get four guesses at the name of this southern Maine community, serene as can be in this sunny scene. Local history buffs like to call the place the first chartered city in America. Those are fighting words to some people up the coast, but an argument can be made — there are few villages in the nation that can trace their roots back to the 1620s and still fewer cities were founded by 1641. Early residents found the haven here to be a particularly snug one. *The Cruising Guide to the Maine Coast* calls it "the most secure harbor between Portsmouth and Portland," and notes that it's long been a fine hurricane hole. The lands around it have not always been so secure. The Englishfolk who made their homes here had some trouble with the French and Indians. The Candlemas Day Massacre is a notable example — the settlement was nearly obliterated during Indian raids. Good plucky Mainers that they were, the townspeople rebuilt rather than leave, which, as a local historian notes, was forbidden under the law of the day anyway — better these folks get killed, the thinking must have been, than those in Boston. These were the sorts of nasty English laws that ticked off the Colonists, and when separation from England became a hot idea, residents here were largely behind it — they had a tea party even before their brothers in Boston did, raiding a store where British tea was kept while posing as "Pequawket Indians." When prosperity returned after the war, townspeople turned back to fishing, farming, and shipbuilding, which would keep them employed until the explosion of tourism that hit the community after the Civil War. Turn to page 101 to see where to find it.

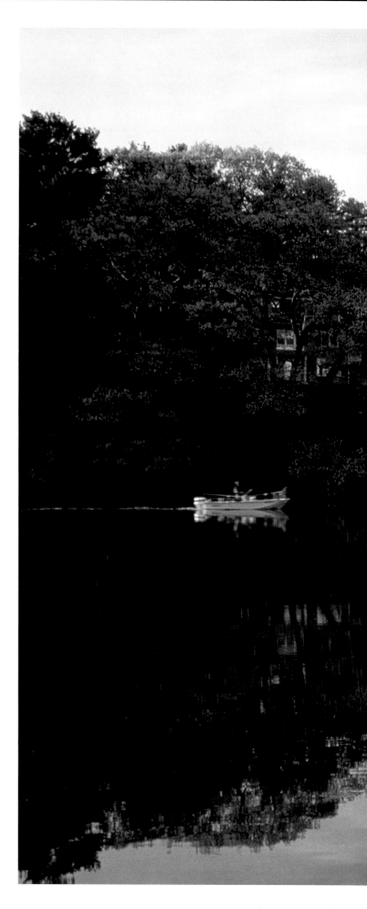

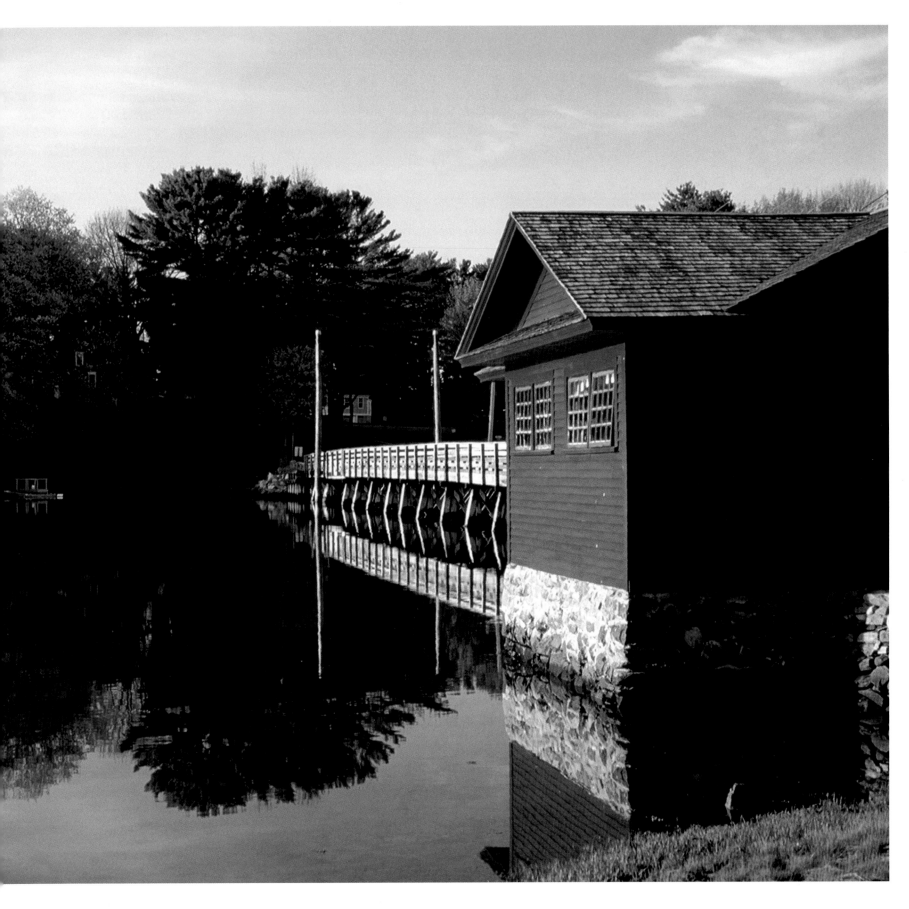

The answers. And more...

Orrs, Bailey Island pages 6–7
Population: 500.
Population density: 216 people per square mile.
Median household income: $40,611.
ZIP Code: 04003.
Best place to grab lunch: Cook's Lobster House.
Best place to lay your head: you have your pick, but the Log Cabin may be the most fun.
Local landmarks: the bridge, Land's End, Giant Steps, Mackerel Cove.
Renowned residents: freed slave William Black, Jungian psychoanalysts Eleanor Bertine, Esther Harding, and Kristine Mann.
Getting there from here: Take Route 24.

Head Tide, Alna pages 8–9
Population: 675.
Population density: 32 people per square mile.
Median household income: $43,125.
ZIP Code: 04535.
Best place to grab lunch: the only place is the local general store.
Best place to lay your head: the next town over.
Local landmarks: this village.
Renowned residents: poet Edwin Arlington Robinson, famous Maine writer Andrew Vietze.
Getting there from here: Take Route 194 or 218.

Corinth pages 10–11
Population: 2,500.
Population density: 63 people per square mile.
Median household income: $37,318.
ZIP Code: 04427.
Best place to grab lunch: you could grab some veggies at Thomas Farm.
Best place to lay your head: in a neighboring town.
Local landmarks: the bridge.
Renowned residents: George Emery, governor of the Utah Territory and the man for whom Emery County, Utah, was named.
Getting there from here: Take the Cushman Road.

Phippsburg pages 12–13
Population: 2,106.
Population density: 73 people per square mile.
Median household income: $46,739.
ZIP Code: 04562.
Best place to grab lunch: Anna's Water's Edge.
Best place to lay your head: the B-and-B named after the beach.

Local landmarks: a few forts and beaches.
Renowned residents: George P., for whom much around here is named.
Getting there from here: Take Route 209.

Newcastle pages 14–15
Population: 1,748.
Population density: 60 people per square mile.
Median household income: $43,000.
ZIP Code: 04553.
Best place to grab lunch: lots of options across the bridge.
Best place to lay your head: The inn named for the town.
Local landmarks: Dodge Point.
Renowned residents: Colonel David Dunbar.
Getting there from here: Take Route 1.

D.T. Sheridan Wreck, Monhegan pages 16–17
Population: 75.
Population density: 75 people per square mile.
Median household income: $26,250.
ZIP Code: 04852.
Best place to grab lunch: Carina.
Best place to lay your head: can't go wrong anywhere, local house or inn, depending on whether you want cool or comforts.
Local landmarks: the light, this wreck.
Renowned residents: artists Rockwell Kent, Edward Hopper, George Bellows.
Getting there from here: Take the ferry.

Daicey Pond, Baxter State Park pages 18–19
Population: Maybe 35 in high summer.
Population density: maybe a couple of people per square mile.
Median household income: $0; no households.
ZIP Code: 04462 is closest.
Best place to grab lunch: Big Niagara Falls.
Best place to lay your head: Cabin 5, Mt. View.
Local landmarks: a very large mountain.
Renowned residents: moose, bears, foxes.
Getting there from here: Take "the State Road."

Cundy's Harbor, Harpswell pages 20–21
Population: 5,239.
Population density: 216 people per square mile.
Median household income: $40,611.
ZIP Code: 04079.
Best place to grab lunch: Holbrook's Lobster House.
Best place to lay your head: the Captain's Watch Bed and Breakfast.

Local landmarks: New Meadows River and Holbrook's Wharf.
Renowned residents: Senator Margaret Chase Smith.
Getting there from here: Route 24, then local roads.

Fort Point Light, Stockton Springs pages 22–23
Population: 1,481.
Population density: 76 people per square mile.
Median household income: $37,050.
ZIP Code: 04981.
Best place to grab lunch: Wyman's Seafood.
Best place to lay your head: the Farm at French's Point, hands down.
Local landmarks: the lighthouse, the park, Hersey Retreat.
Renowned residents: Harriet Hichborn, early photographer.
Getting there from here: Take Route 1.

Desert of Maine, Freeport pages 24–25
Population: 7,800.
Population density: 224 people per square mile.
Median household income: $52,023.
ZIP Code: 04032.
Best place to grab lunch: the Corsican never disappoints, and Buck's Naked BBQ wins polls.
Best place to lay your head: the Harraseeket Inn.
Local landmarks: some shops, Mast Landing, Wolfe's Neck Woods.
Renowned residents: humorist John Gould, Arctic explorer Donald MacMillan, Olympian Joan Benoit Samuelson.
Getting there from here: Take Desert Road.

Big Squaw, Greenville pages 26–27
Population: 1,623.
Population density: 38 people per square mile.
Median household income: $43,000.
ZIP Code: 04441.
Best place to grab lunch: Flatlander's.
Best place to lay your head: Blair Hill Inn.
Local landmarks: a lake, a mountain, a steamer named after the Mountain of the People of Maine.
Renowned residents: early settler Nathaniel Haskell.
Getting there from here: Take Route 15.

South Thomaston pages 28–29
Population: 1,416.
Population density: 129 people per square mile.
Median household income: $43,594.
ZIP Code: 04858.
Best place to grab lunch: Waterman's Beach Lobster — and don't forget to get a piece of pie.
Best place to lay your head: Weskeag Inn.

Local landmarks: the reversing falls.
Renowned residents: dueling Congressman Jonathan Cilley, Senator John Ruggles.*
Getting there from here: Take Route 73.
*these politicians were technically from Thomaston, but South Thomaston was part of that town when they lived there.

Skowhegan **pages 30–31**
Population: 8,824.
Population density: 150 people per square mile.
Median household income: $28,390.
ZIP Code: 04976.
Best place to grab lunch: Old Mill Pub.
Best place to lay your head: Belmont Motel seems to be the favorite among the community's motel contingent.
Local landmarks: the art school, the big Indian, the fair, the mills, the bridge.
Renowned residents: a raft of politicians – Abner Coburn, Stephen Coburn, Forrest Goodwin, Samuel Gould, David Kidder, Clyde Smith, Margaret Chase Smith. Artist "Blackie" Langlais for a while.
Getting there from here: Take Route 201.

Peaks-Kenny State Park, Dover-Foxcroft **pages 32–33**
Population: 4,211.
Population density: 62 people per square mile.
Median household income: $30,164.
ZIP Code: 04426.
Best place to grab lunch: Abel Blood's Pub.
Best place to lay your head: Bear's Den Motel has some nice pine-walled cabins.
Local landmarks: a park, the academy.
Renowned residents: baseballer Clarence Blethen, singer-songwriter Dave Mallett, temperance maven Lillian Stevens.
Getting there from here: Take State Park Road.

Mars Hill Mountain **pages 34–35**
Population: 1,480.
Population density: 109 people per square mile.
Median household income: $24,083.
ZIP Code: 04758.
Best place to grab lunch: Al's Diner on Main.
Best place to lay your head: My Sunset Cabins at the foot of the hill.
Local landmarks: you're looking at it.
Renowned residents: Al.
Getting there from here: Route 1.

Balance Rock, Acadia National Park **pages 36–37**
Population: 4,820.
Population density: 114 people per square mile.
Median household income: $37,481.

ZIP Code: 04609.
Best place to grab lunch: so many options, but you couldn't go wrong with Cafe This Way, 2 Cats, or Rosalie's.
Best place to lay your head: The intriguingly named Ullikana.
Local landmarks: Bar Island, the Shore Path, a park.
Renowned residents: Nobel Peace Prize winner Jane Addams, Presidential candidate James G. Blaine, landscape architect Beatrix Farrand, publishing magnate Joseph Pulitzer, actress Katharine Hepburn, among many others.
Getting there from here: Take Route 3.

Castle Island, Belgrade **pages 38–39**
Population: 2,978.
Population density: 69 people per square mile.
Median household income: $39,000.
ZIP Code: 04917.
Best place to grab lunch: Maybe right in these camps, which are famous for their homemade soups and weekly barbecue.
Best place to lay your head: Again, where better than this? The Village Inn is very popular, too.
Local landmarks: Village Inn, which is known worldwide for its roast duckling.
Renowned residents: essayist E.B.White, writer Ernest Thompson, Maine governors Lot and Anson Morrill.
Getting there from here: Take Route 27.

Asticou Azalea Garden, Northeast Harbor **pages 40–41**
Population: 2,109.
Population density: 57 people per square mile.
Median household income: $41,321.
ZIP Code: 04662.
Best place to grab lunch: the inn of the same name.
Best place to lay your head: Harborside Inn.
Local landmarks: the harbor, the gardens.
Renowned residents: landholder Antoine Laumet, who held the deed to everything around here.
Getting there from here: Take Route 198.

Chauncey Creek, Kittery **pages 42–43**
Population: 9,543.
Population density: 535 people per square mile.
Median household income: $52,200.
ZIP Code: 03905.
Best place to grab lunch: the lobster pound right here — or Bob's Clam Hut.
Best place to lay your head: Portsmouth Harbor Inn and Spa.
Local landmarks: big bridge, shipyard.
Renowned residents: soldier Sir William Pepperrell, writer William Dean Howells, poet Celia Thaxter, newscaster Randy Price, Seinfeld actor John O' Hurley (J.

Peterman).
Getting there from here: Take Route 103.

Phillips **pages 44–45**
Population: 930.
Population density: 19 people per square mile.
Median household income: $30,579.
ZIP Code: 04966.
Best place to grab breakfast: JB's Kitchen has those homemade donuts you're looking for.
Best place to lay your head: the options are very limited here. Echo Valley Lodge might be your pick, down on the Sandy.
Local landmarks: Daggett Rock, one of the largest glacial erratics on earth at 31 feet tall.
Renowned residents: musician Ray LaMontagne, politician Minnie Craig, the first female speaker of a state House of Representatives.
Getting there from here: Take Route 4.

Popham Beach, Phippsburg **pages 46–47**
Population: 2,106.
Population density: 73 people per square mile.
Median household income: $46,739.
ZIP Code: 04562.
Best place to grab lunch: Spinney's.
Best place to lay your head: The Eyrie on Morse Mountain or Hermit Island if you have a tent.
Local landmarks: this beach, Small Point, a few forts, Pond Island Light.
Renowned residents: Daniel, Jonathan, and Wyman Morse, who started the Morse line in Maine.
Getting there from here: Take Route 209.

Islesboro **pages 48–49**
Population: 603.
Population density: 42 people per square mile.
Median household income: $39,643.
ZIP Code: 04848.
Best place to grab lunch: Island Market for to-go items or that little lunch stand near the ferry landing because you can't beat the view.
Best place to lay your head: one of the cool lean-tos at Warren Island State Park.
Local landmarks: the light, Warren Island, Dark Harbor House.
Renowned residents: dramatist Ruth Draper, illustrator Charles Dana Gibson, a bunch of actors and actresses, including Chris O'Donnell.
Getting there from here: Take the ferry.

Livermore Falls **pages 50–51**
Population: 3,227.
Population density: 163 people per square mile.

Median household income: $30,102.
ZIP Code: 04254.
Best place to grab lunch: Chuckwagon Restaurant.
Best place to lay your head: down the road.
Local landmarks: the mills.
Renowned residents: poet Louise Bogan.
Getting there from here: Take Route 133

Manana, Monhegan **pages 52–53**
Population: 75.
Population density: 75 people per square mile.
Median household income: $26,250.
ZIP Code: 04852.
Best place to grab lunch: Carina.
Best place to lay your head: can't go wrong anywhere, local House or Inn, depending on whether you want cool or comforts.
Local landmarks: Cathedral Woods, Black Head.
Renowned residents: some Wyeths, actor Zero Mostel, socially conscious entrepreneurs Tom and Kate Chappell, hermit Ray Phillips.
Getting there from here: Take the ferry.

UMaine, Orono **pages 54–55**
Population: 9,114.
Population density: 500 people per square mile.
Median household income: $30,619.
ZIP Code: 04469.
Best place to grab lunch: Pat's Pizza or the Harvest Moon Deli.
Best place to lay your head: check with the local chamber.
Local landmarks: a school.
Renowned residents: poet Constance Hunting, writer Dorothy Clarke Wilson, Maine governor Israel Washburn, Penobscot Chief Joseph, Miss Maine 2006 Katee Stearns.
Getting there from here: Take Route 2.

Pejepscot Mill, Topsham **pages 56–57**
Population: 9,100.
Population density: 284 people per square mile.
Median household income: $47,682.
ZIP Code: 04086.
Best place to grab lunch: Old Munich Restaurant for brats, Sea Dog for burgers and brews.
Best place to lay your head: Black Lantern B-and-B.
Local landmarks: Fair, strip malls.
Renowned residents: writer Elijah Kellogg, Little Round Top hero and Portland mayor Holman Melcher.
Getting there from here: Take Route 201.

Whalesback, Aurora **pages 58–59**
Population: 121.
Population density: 3 people per square mile.

Median household income: $26,250.
ZIP Code: 04408.
Best place to grab lunch: that brown bag you brought with you.
Best place to lay your head: farther down the road.
Local landmarks: this esker.
Renowned residents: no one's telling.
Getting there from here: Take the Airline.

Brown's Head Light, Vinalhaven **pages 60–61**
Population: 1,235.
Population density: 49 people per square mile.
Median household income: $34,087.
ZIP Code: 04863.
Best place to grab lunch: the Harbor Gawker.
Best place to lay your head: We like the Tidewater Motel.
Local landmarks: Lane's Island Preserve, this beacon and Heron Neck and Saddleback Ledge lights.
Renowned residents: artist Robert Indiana, children's book author Margaret Wise Brown, Standard Oil partner Brewster Jennings, photographer Eliot Elisofon, Massachusetts governor Leverett Saltonstall.
Getting there from here: Take the ferry.

Eagle Island, Harpswell **pages 62–63**
Population (of town in which island lies): 5,239.
Population density: 216 people per square mile.
Median household income: $40,611.
ZIP Code: 04003.
Best place to grab lunch: that brown bag you brought.
Best place to lay your head: a tent on a neighboring island.
Local landmarks: the summerhouse.
Renowned residents: that would be cheating.
Getting there from here: Take a charter boat.

Oak Grove School, Vassalboro **pages 64–65**
Population: 4,047.
Population density: 91 people per square mile.
Median household income: $37,923.
ZIP Code: 04989.
Best place to grab lunch: talk of the town is the Grand View Topless Coffee Shop, but it's only serving java and donuts, sorry.
Best place to lay your head: rental cottage on the lake.
Local landmarks: the school.
Renowned residents: writer Holman Day, psychologist Henry Goddard.
Getting there from here: Take Route 201.

Mark Island, Winter Harbor **pages 66–67**
Population: 988.
Population density: 69 people per square mile.
Median household income: $28,571.

ZIP Code: 04693.
Best place to grab lunch: Fisherman's Inn.
Best place to lay your head: Main Stay Cottages.
Local landmarks: Schoodic Point.
Renowned residents: landowner Roxanne Quimby, singer Nelson Eddy, actress Margaret Sullavan.
Getting there from here: Take Route 186.

Fryeburg **pages 68–69**
Population: 3,083.
Population density: 53 people per square mile.
Median household income: $34,333.
ZIP Code: 04037.
Best place to grab lunch: BBQ at 302 West.
Best place to lay your head: Admiral Peary House.
Local landmarks: the fair, the academy.
Renowned residents: Hopalong Cassidy creator Clarence Mulford, Arctic explorer Robert Peary, Nescambious, the Abenaki chief who was knighted by the French.
Getting there from here: Take Route 302.

Leonard's Mills, Bradley **pages 70–71**
Population: 1,242.
Population density: 25 people per square mile.
Median household income: $37,163.
ZIP Code: 04411.
Best place to grab lunch: Claudia's Seafood followed by a cone from Spencer's Market.
Best place to lay your head: Paradise Cabins.
Local landmarks: the logging museum.
Renowned residents: Leonard?
Getting there from here: Take Route 178.

Vinalhaven **pages 72–73**
Population: 1,235.
Population density: 49 people per square mile.
Median household income: $34,087.
ZIP Code: 04863.
Best place to grab lunch: the Harbor Gawker.
Best place to lay your head: We like the Tidewater Motel.
Local landmarks: Lane's Island Preserve, Brown's Head and Heron Neck and Saddleback Ledge lights.
Renowned residents: artist Robert Indiana, children's book author Margaret Wise Brown, Standard Oil partner Brewster Jennings, photographer Eliot Elisofon, Massachusetts governor Leverett Saltonstall.
Getting there from here: Take the ferry.

Cathedral Pines, Eustis **pages 74–75**
Population: 685.
Population density: 18 people per square mile.
Median household income: $28,000.
ZIP Code: 04936.
Best place to grab lunch: Trail's End Steakhouse, unless

you want to leave town.
Best place to lay your head: right here by the lake.
Local landmarks: the big, unique lake.
Renowned residents: U.S. Tax Court judge Lawrence Wright.
Getting there from here: Take Route 27.

Waldo-Hancock Bridge, near Bucksport **76–77**
Population: 4,908.
Population density: 95 people per square mile.
Median household income: $34,812.
ZIP Code: 04416.
Best place to grab lunch: not far from the the bridge, at Kravings.
Best place to lay your head: Williams Pond Lodge.
Local landmarks: a fort, Alamo Theatre, a gravestone.
Renowned residents: Civil War General Edward Winslow Hinks, actors William and Dustin Farnum, a witch.
Getting there from here: Take Route 1.

The Cuckolds, Southport **pages 78–79**
Population: 684.
Population density: 127 people per square mile.
Median household income: $38,125.
ZIP Code: 04576.
Best place to grab lunch: Robinson's Wharf.
Best place to lay your head: Newagen Inn.
Local landmarks: this light, Hendricks Head Light.
Renowned residents: writer Rachel Carson, professor Hart Leavitt, Disney illustrator Gustaf Tenggren, Modernist painter Claggett Wilson.
Getting there from here: Take Route 27.

Dodge Point, Newcastle **pages 80–81**
Population: 1,748.
Population density: 60 people per square mile.
Median household income: $43,000.
ZIP Code: 04553.
Best place to grab lunch: the Publick House.
Best place to lay your head: The inn named for the town.
Local landmarks: Lincoln Academy.
Renowned residents: the family home of Francis Perkins, the first female U.S. Secretary of Labor and first female member of a presidential cabinet, is in town.
Getting there from here: Take Business Route 1 or the River Road.

Rockland **pages 82–83**
Population: 7,609.
Population density: 589 people per square mile.
Median household income: $30,209.
ZIP Code: 04841.
Best place to grab lunch: Thorndike Creamery.
Best place to lay your head: Berry Manor Inn.

Local landmarks: breakwater, lighthouse, art museum.
Renowned residents: composer Walter Piston, sculptor Louise Nevelson, actress Maxine Elliott, poets Leo Connellan and Edna St. Vincent Millay, Maine governor William T. Cobb.
Getting there from here: Take Route 17.

Fort Edgecomb, Edgecomb **pages 84–85**
Population: 1,091.
Population density: 60 people per square mile.
Median household income: $43,833.
ZIP Code: 04556.
Best place to grab lunch: Bintliff's Ocean Grill is the highest-profile eatery and serves up decent seafood.
Best place to lay your head: the resort named after the river.
Local landmarks: the fort.
Renowned residents: folk artist Earl Cunningham.
Getting there from here: Take the Fort Road.

Little River Dam, Belfast **pages 86–87**
Population: 6,381.
Population density: 188 people per square mile.
Median household income: $32,400.
ZIP Code: 04915.
Best place to grab lunch: Chase's Daily on Main Street.
Best place to lay your head: 1 Church Street, just so you can say you stayed at the White House.
Local landmarks: architecture downtown, the National Theater Workshop for the Handicapped, Perry's Nut House.
Renowned residents: Maine governor William Crosby, Congressman Seth Milliken, mesmerist Phineas Quimby, *General Hospital*'s "Laura," but she's moved back to California.
Getting there from here: Take Route 1.

Thunder Hole, Acadia National Park **pages 88–89**
Population: 4,820.
Population density: 114 people per square mile.
Median household income: $37,481.
ZIP Code: 04609.
Best place to grab lunch: the Opera House Internet Cafe for something to munch, or the Downeast Deli for a boxed lunch to take to the shore.
Best place to lay your head: A Yellow House.
Local landmarks: a pond, a mountain, a park.
Renowned residents: conservationist George Dorr, John Stewart Kennedy, George Vanderbilt, philanthropist Sir Harry Oakes.
Getting there from here: Take Schooner Head Road.

Fort Halifax, Winslow **pages 90–91**
Population: 7,743.

Population density: 210 people per square mile.
Median household income: $39,580.
ZIP Code: 04901.
Best place to grab lunch: Big G's Deli.
Best place to lay your head: up the road.
Local landmarks: the fort, Big G's .
Renowned residents: Tiger Woods' caddy Mike Cowan, politicians Thomas Rice, Charles Fletcher Johnson, and Joshua Cushman.
Getting there from here: Take Route 201.

Sebago Lake **pages 92–93**
Population: 1,433.
Population density: 44 people per square mile.
Median household income: $40,391.
ZIP Code: 04029.
Best place to grab lunch: Texas Rose Cafe.
Best place to lay your head: a rental cabin.
Local landmarks: the lake, Douglas Mountain.
Renowned residents: William Fitch, the Porter brothers.
Getting there from here: Take Route 114.

James School, Presque Isle **pages 94–95**
Population: 9,511.
Population density: 126 people per square mile.
Median household income: $29,325.
ZIP Code: 04769.
Best place to grab lunch: big ol' burgers at the Irish Setter Pub on Main, panini rolls and Thai vegetable soup at Cafe Sorpreso.
Best place to lay your head: the Northeastland Hotel or Convention Center, both have their partisans.
Local landmarks: UMaine campus, Northern Maine Museum of Science, air museum, state park.
Renowned residents: authors John Crowley and Lynn Flewelling, singer-songwriter Ellis Paul, baseball player Ron Tingley, paleontologist Jack Sepkoski.
Getting there from here: Take Route 1.

York River, York **pages 96–97**
Population: 12,854.
Population density: 234 people per square mile.
Median household income: $56,171.
ZIP Code: 03909.
Best place to grab lunch: Wild Willy's for burgers, Flo's for dogs, Frankie and Johnnies for more eclectic options, Lucia's Kitchen for spice, Goldenrod or Brown's for dessert.
Best place to lay your head: local harbor inn or Dockside Guest Quarters.
Local landmarks: beach, Cape Neddick Light (The Nubble).
Renowned residents: astronaut Christopher Cassidy, poet May Sarton.
Getting there from here: Take Route 1.